IN FOCUS

HILL AND ADAMSON

PHOTOGRAPHS

from

THE J. PAUL GETTY

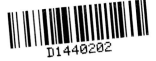

The J. Paul Getty Museum

Los Angeles

In Focus
Photographs from the J. Paul Getty Museum
Weston Naef, *General Editor*

© 1999 The J. Paul Getty Museum
1200 Getty Center Drive
Suite 1000
Los Angeles, California 90049-1687

Christopher Hudson, *Publisher*
Mark Greenberg, *Managing Editor*

Library of Congress
Cataloging-in-Publication Data

J. Paul Getty Museum.
 In focus : Hill and Adamson / photographs from
the J. Paul Getty Museum.
 p. cm. — (In focus)
 ISBN 0-89236-540-4
 1. Photography, Artistic. 2. Portrait photography.
3. Hill, David Octavius, 1802–1870. 4. Adamson,
Robert, 1821–1848. 5. J. Paul Getty Museum—
Photograph collections. 6. Photograph collections—
California—Los Angeles. 7. Calotype. 8. Photog-
raphers—Scotland—Biography. I. Title. II. Series:
In focus (J. Paul Getty Museum)
TR651.J68 1999
779'.092'2—dc21 98-4127
 CIP

Contents

Foreword

As the first title in the In Focus series to deal with a partnership, it is fitting that the subject should be the first professional collaboration in the history of photography: David Octavius Hill and Robert Adamson. Their story is a remarkable one. Brought together by a rupture within the Church of Scotland in 1843, these two seemingly opposite men forged an alliance that was to be short-lived due to Adamson's untimely death at the age of twenty-six. Yet in less than five years the pair produced thousands of pictures, each printed outdoors in direct sunlight, quite a challenge in the wet climate of Scotland.

Although photography was announced almost simultaneously in France and England in 1839, through the work of Hill and Adamson Scotland became the third important center for early photography. Drawing inspiration from Dutch genre painting, Scottish portraiture, and the literary works of Sir Walter Scott, the pair created images that exploited the medium of paper photography in a way that has rarely been surpassed.

The work of Hill and Adamson was discussed in a colloquium held at the Getty Center on July 18, 1997. The participants included Anne M. Lyden, A. D. Morrison-Low, Weston Naef, Jonathan Reff, Sara Stevenson, and Michael Wilson as well as David Featherstone, the moderator and condenser of the transcript. My thanks are offered to all, especially to Anne Lyden for coordinating the project and providing the interpretive texts for the plates.

In addition to those individuals listed on the last page of this book, many others were involved: Susan Adam, Carol Cini, Julian Cox, Marc Harnly, Marcia Lowry, Ernie Mack, Ted Panken, Jean Smeader, Dusan Stulik, and Fred Williams. To Weston Naef, the originator and general editor of the In Focus series, I am particularly grateful.

Deborah Gribbon,
Deputy Director and Chief Curator

Introduction

In July 1843 in Edinburgh, Scotland, the well-established painter David Octavius Hill (1802–70) entered into a photographic partnership with the young engineer Robert Adamson (1821–48). Coming from different disciplines and being about twenty years apart in age, the two men were an unlikely creative team. Their collaboration, which was to last just four and a half years, produced a phenomenal body of work that is still ranked as among the finest in the history of this art form.

Forged only four years after the invention of photography was announced, the partnership was the first to jointly author pictures. Using the negative-positive paper process developed by William Henry Fox Talbot (1800–1877), Hill and Adamson created some of the earliest examples of fine art photography, where the image was valued as more than just documentary evidence. The calotype (meaning "beautiful image") had a broad tonal range and displayed a painterly quality that was due in part to the absorbent paper fibers, which caused the likeness to soften. For Hill, this was an important characteristic of the medium. As he explained in a letter of January 17, 1848: "The rough and unequal texture throughout the paper is the main cause of the calotype failing in details before the Daguerreotype...and this is the very life of it. They look like the imperfect work of man ... and not the much diminished perfect work of God." Hill and Adamson's prints were often compared to Rembrandt's etchings because of the strong chiaroscuro effect of the photographs.

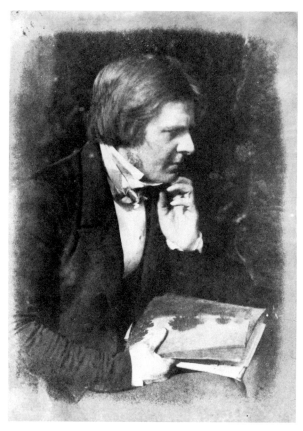

David Octavius Hill and Robert Adamson.
D. O. Hill, R.S.A., 1843–47. Salt print, 21.4 × 15.2 cm.
84.XO.754.4.2.26.

The calotype came to Scotland in 1841 when Talbot sent details of the process to his friend Sir David Brewster (1781–1868), a leading physicist. Brewster, principal of St. Andrews University, enthusiastically shared this knowledge with several of his colleagues, one of whom was Dr. John Adamson (1810–70). After many failed attempts at mastering Talbot's method, Adamson successfully made the first photographic portrait in Scotland in May of that year.

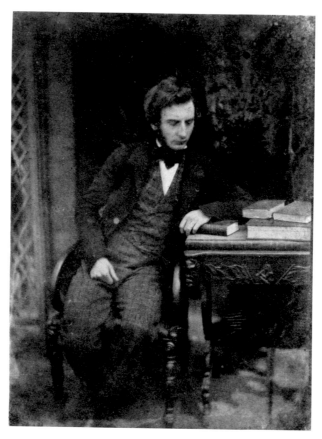

David Octavius Hill and Robert Adamson.
Robert Adamson, 1843–47. Salt print, 20.8 × 15.7 cm.
Scottish National Portrait Gallery.

Adamson began instructing his youngest brother, Robert, in the art of the calotype in 1842. Robert apparently suffered from poor health throughout his life and, instead of pursuing a career in engineering, which seemed too physically demanding, decided to devote himself to photography. He worked with his brother in 1842 and 1843, making photographs in and around St. Andrews. An article in the January 1843 *Edinburgh Review* revealed Robert's intention of establishing a

professional photographic practice in Edinburgh; in May of that year he opened his studio at Rock House, Calton Hill Stairs.

At precisely this moment Edinburgh was the center of a major religious dispute. The Church of Scotland was holding its annual General Assembly in the city, with ministers from all over the country in attendance. There had been growing dissension among some of the members as to the state's involvement in the affairs of the church. This reached a climax when a breakaway group of ministers walked out of the meeting on May 18, 1843, and a few days later officially established the Free Church of Scotland. Many onlookers were present to watch these events unfold, including Hill. Finding himself moved by the spectacle of people standing up for their spiritual beliefs, he decided to embark upon a commemorative painting (see foldout at p. 147 and detail on p. 9).

For Hill, the decision to paint a large historical work was a deviation from the landscapes for which he was known. Choosing to paint the signing of the Free Church declaration that took place at Tanfield Hall on May 23, 1843, presented an indomitable task from the very beginning. Given that the new church was based on a more democratic approach, Hill wished to give each figure an equal presence in the composition. With over five hundred signatories to the Deed of Demission, however, the idea of making preliminary sketches of each person was impractical. At the suggestion of Brewster, Hill met with Robert Adamson and arranged to utilize the relatively new medium of photography, which not only provided a way of obtaining portraits for the painting but also significantly reduced the time involved.

Hill's initial reaction to the photographs was one of incredulity, which was quickly replaced by a fascination and enthusiasm for the art form. Within a number of weeks he entered into a partnership with Adamson. From the beginning the alliance was an ambitious one, with the two men producing Free Church studies, portraits of Edinburgh gentry and literati, architectural views of the city, and documentary images of Newhaven, a small fishing village. Because the calotype process required working outside in strong sunlight, Hill and Adamson were only able to make photographs for part of the year, yet, remarkably, their output was considerable.

Their success seems to have been due to the different talents that each man brought to the collaboration. Very little is known about Adamson; much of

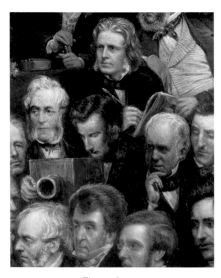

Thomas Annan.
"The Signing of the Deed of Demission" (The Disruption Picture)
by David Octavius Hill (painted 1843–66) (detail), 1866.
Carbon print, 26.6 × 60.2 cm.
The Metropolitan Museum of Art, New York, Gift of Robert O. Dougan, 1976 (1976.516).
Hill included a self-portrait and a portrait of Robert Adamson in the right center of the painting.
Hill is shown with a sketchbook; Adamson, with a camera.

what is known comes from Hill, who was very impressed with him. Describing Adamson's work as "chemical manipulations," Hill hinted that the engineer-turned-photographer knew more about the medium than most practitioners, a fact borne out by the quality and durability of his negatives and prints. There is a lack of pictures of the younger man, suggesting that he was more comfortable behind the camera than in front of it. Hill, by contrast, was the most popular subject for the partnership, appearing in a plethora of portraits, often in varying guises. He utilized photography as a means of further exploring composition and subject, perhaps seeing it as an extension of his previous work in drawing, lithography, and painting.

Hill and Adamson intended to produce sumptuous albums of calotypes for general sale and went so far as to advertise the proposed titles in a local newspaper in 1844. Although the partnership did produce several bound volumes of St. Andrews views in 1846 (see p. 145), none of the advertised albums was ever realized, in spite of the existence of a large portfolio of prints from which to make a

selection. Despite Hill's efforts at soliciting London agents, for the most part the main retail source for the calotypes was a gallery run by his brother Alexander (1800–1866) on Edinburgh's Princes Street. Both Hill and Adamson invested a lot of time and money into the business, yet commercial success eluded them.

The partnership came to a tragic end in January 1848 when Robert Adamson died at the age of twenty-six. Hill did not abandon photography upon the death of his colleague, but his involvement was never the same again. A collaboration with John Adamson was considered but failed to materialize; however, in the early 1860s Hill did enter into another alliance, this time with Alexander McGlashan (d. 1877), an engraver and printer from Glasgow. Interestingly, their work together did not approach the quality of the earlier calotype masterpieces that Hill had created in conjunction with Robert Adamson. The chemistry that existed between the artist and the engineer was the essential ingredient in the success of their pictures.

By far the largest holdings of Hill and Adamson's work still remain in Scotland. The Scottish National Portrait Gallery in Edinburgh has more than 2,400 of their prints, while the special collections department of the University of Glasgow has the most paper negatives, numbering 491. In the Getty Museum's collection there are 6 negatives and 463 positive prints, many of which are contained in albums. This book represents a selection of some of the finest examples from this substantial body of work. The Hill and Adamson material was acquired from some of the most important collectors of photographs in the twentieth century: Bruno Bischofberger, Arnold Crane, André Jammes, Volker Kahmen/Georg Heusch, and Samuel Wagstaff, Jr. In 1988 the Museum purchased 50 of the 500 images mounted in albums that Hill had presented to the Royal Scottish Academy in 1852 (the albums were broken up in 1975 when the Academy decided to sell the pictures). Complementing the work of other nineteenth-century British photographers represented in the collection, such as Talbot, Roger Fenton (1819–69), and Julia Margaret Cameron (1815–79), the Hill and Adamson compilation is an important holding for the Museum. The collection of calotypes and negatives represents not only the dawn of Scottish photography but also one of the first true examples of fine art photography.

Anne M. Lyden, *Curatorial Assistant, Department of Photographs*

Plates

A Note to the Reader

Most of Hill and Adamson's photographs cannot be dated any more precisely than 1843 to 1847, the duration of the partnership. The plates in this book, therefore, have been arranged more by pictorial groupings than by a strict chronology. Exact dates are provided where possible.

Hill and Adamson's calotypes are reddish brown in tone, which is not reflected by the reproductions in this volume. Some of the calotypes are untrimmed, showing their full sheet state (see, for example, pls. 14–16).

PLATE I

Sir David Brewster

1843–44

Salt print
19.4 × 13.8 cm
84.XM.445.15

Two important factors led to the introduction of the calotype into Scotland: the friendship between Talbot and Brewster, and the establishing in 1840 of the penny postage system in the British Isles, which provided a fairly inexpensive and reliable way to send mail. Talbot not only posted examples of his photographic work to Brewster, he also supplied details of the chemical processes involved. Brewster's sharing of this information with his colleagues at St. Andrews University, namely Dr. John Adamson and Maj. Hugh Lyon Playfair (1786–1861), led to Adamson's success at creating the first calotype in Scotland.

The small circle of amateur enthusiasts grew with the addition of Robert Adamson in 1842. He appeared to excel in the new art. On May 9, 1843, Brewster informed Talbot that Adamson "goes tomorrow to Edinr. to prosecute, as a Profession, the calotype. He has made brilliant progress and done some of the very finest things both in Portrait and Landscape."

Brewster was also responsible for the partnership between Hill and Adamson. After learning of Hill's decision to commemorate the formation of the Free Church of Scotland with a large painting, Brewster introduced them, seeing the opportunity for photography to assist in the process of making preliminary studies. In a July 3, 1843, letter to Talbot, Brewster explained: "I got hold of the artist—showed him the Calotype, & the eminent advantage he might derive from it in getting likenesses of all the principal characters before they were dispersed to their respective homes. He was at first incredulous, but went to Mr. Adamson, and arranged with him preliminaries for getting all the necessary portraits."

Brewster himself was a member of the newly formed Free Church of Scotland. Using this calotype as a model, Hill included Brewster's portrait in the Disruption Picture (he is the fifth person to the left of the central pulpit).

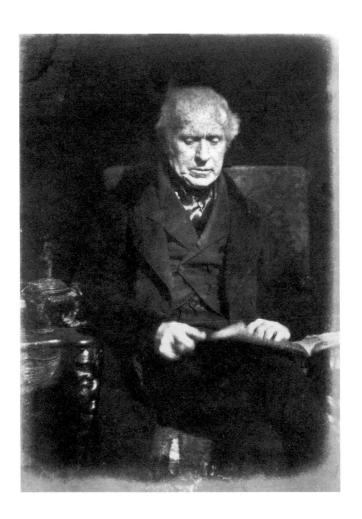

PLATE 2

Thomas Chalmers, D.D.

Circa 1843

Salt print
14 × 10.8 cm
84.XO.734.4.1.11

Hill was a respected artist and secretary to the Royal Scottish Academy when, in July 1843, he entered into partnership with Adamson. Approaching photography from an artistic background, Hill saw his role as that of selecting and arranging the subjects. Initially he viewed the calotypes as sketches that would aid him in his grand painting scheme.

Hill's decision to portray a religious event had its precedent in the work of the esteemed Scottish artist Sir David Wilkie (1785–1841), who had created a series of paintings dealing with John Knox (c. 1514–72), the leader of the Scottish Reformation. Hill would have been well aware of Wilkie's work, as the Academy had acquired an oil of his as recently as 1842. This calotype of Thomas Chalmers (1780–1847) bears a strong similarity in composition to a painting Wilkie made of Knox preaching at St. Andrews, where the minister is gesticulating from the pulpit.

Chalmers, also a minister and social reformer, was very much involved in the dissension within the Church of Scotland during the 1840s. Described by a fellow member of the clergy as "the Church's trusted leader—the powerful and unflinching champion of its independence," Chalmers became the first moderator of the General Assembly of the Free Church of Scotland. Hill had originally planned to have Chalmers—at the central pulpit—as more of a predominant figure in the Disruption Picture; this portrait relates to earlier drawings for the canvas.

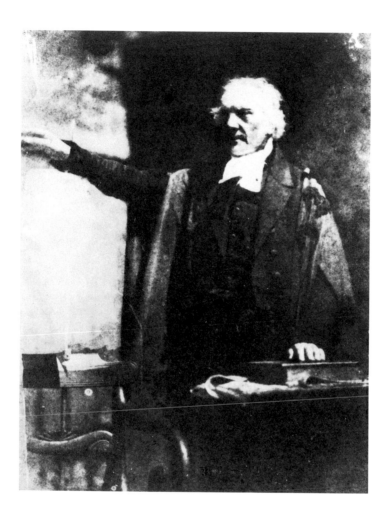

PLATE 3

Free Church Committee

October 19, 1843

Salt print
14.3 × 18.6 cm
84.XZ.574.125

According to an inscription supplied by Brewster, this group portrait was made in Glasgow at the Free Church Assembly, held in October 1843. The subjects are, from left to right, Lord Breadalbane (1796–1862), Brewster, Rev. Dr. David Welsh (1793–1845), James Hamilton (1799–1851), and Alexander Earle Montieth (1793–1861). Welsh was a central figure in the religious dispute; not only had he been the moderator of the Church of Scotland before the split, he was also the minister who read the statement of protest and led the dissenters in their walkout from the May meeting.

Hill and Adamson traveled to Glasgow to obtain this and other portraits of ministers for Hill's painting. This trip was probably one of the first that the artists made together outside of Edinburgh. The image, while not as sophisticated as later group portraits (see pl. 29), was most likely taken in a makeshift studio that the photographers set up at the meeting.

Hill and Adamson's work varied in print quality and tonality. This was due to the newness of the calotype process and the fact that the materials and procedures were still being perfected. In this example, the image appears grainy and slightly faded around the edges, a common condition in very early photographs.

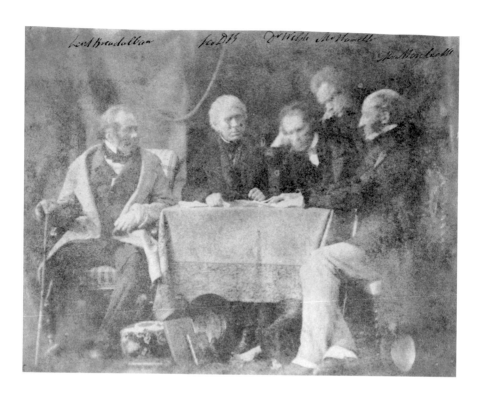

PLATE 4

Rev. James Julius Wood, Greyfriars Church

October 22, 1843

Salt print
19.9 × 14.2 cm
84.XM.263.2

The Rev. James Julius Wood (1800–1877) was chaplain to the 42nd Gordon High-landers, a group of soldiers stationed on the island of Malta. Hill used this calo-type as the basis for a portrait of Wood in the Disruption Picture, even though the minister may not have been present at the signing ceremony (Wood is shown above and to the left of the atlas in the right fore-ground). As with Brewster (pl. 1), Wood is pictured older in the painting than in the photograph. It took Hill more than twenty years to finish the oil; during this time he evidently decided to update the appear-ance of many of the sitters, aging them by adding beards, spectacles, and gray hair.

This use of artistic license also extended to Hill and Adamson's photographs. The original negative for this plate was altered to include a very specific reference to Wood's position—the title *Scotch Church Malta 1843* was drawn in ink on the book he is holding (Hill's inscription at the bottom of the negative provides the date of the image and identifies Wood's parish but incorrectly gives his first name as John). Also, faint traces of a headrest, an apparatus used in many of the earlier prints as a device for limiting the movement of a sitter, can be seen, indicating that the negative was changed in an attempt to mask this tool. Hill and Adamson obviously felt compelled to adjust the photograph in order to create a specific, finished image that went beyond a kind of preparatory sketch for the painting. In other words, they were view-ing the calotype as a work of art unto itself.

PLATE 5

Sir William Allan

November 1843

Salt print
15.4 × 11.3 cm
88.XM.57.46

With the recognition that their photographs could in themselves be finished works of art, Hill and Adamson began to photograph subjects other than ministers. Portraits of eminent sitters from Edinburgh society were undertaken concurrently with the images pertaining to Hill's painting scheme.

One of the most notable portraits from this time is that of the artist Sir William Allan (1782–1850). Elected president of the Royal Scottish Academy in 1838, eight years after Hill became its secretary, Allan, like his friend Sir David Wilkie, painted scenes from Scottish history and of the formation of the Church of Scotland. He was also known for his large canvases of exotic places and for being a keen collector of Circassian objects, particularly costumes and armor. In this photograph he is seen standing with a shield and a sword, presumably examples from his own collection. The forms of the wooden chair and the blade are gently echoed in Allan's stance— his left arm extends out to the back of the chair, echoing the armrest, while his right arm recalls the diagonal placement of the sword. The photograph was so successful that it was the source for an engraving in the book *Scottish Art and National Encouragement*, published in 1846.

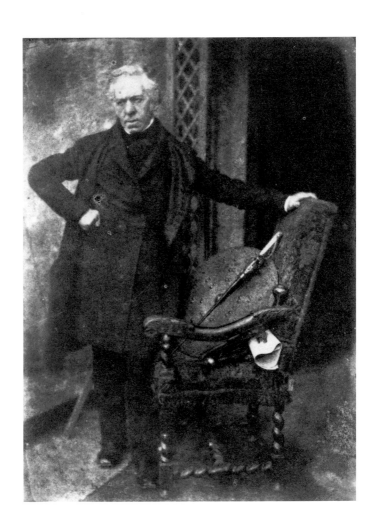

PLATE 6

Afghans

1843

Salt print
20.7 × 14.5 cm
84.XM.131.9

Hill and Adamson made a number of por-
traits where the figures are dressed in
costumes. This reflected the mid-nineteenth-
century interest in the culture and cus-
toms of what were deemed exotic lands. In
the spring of 1843 the *Edinburgh Evening
Courant* reported on two fancy dress balls
featuring examples of Afghan clothing.
The photographers seem to be capitalizing
on this subject with their full-length
portrait of two Afghans carrying various
weapons.

Denied a recognizable location and
prevented from identifying the models
due to the chain mail hoods that obscure
their faces, the viewer is left only with
details of the costumes. This apparent
vagueness is in keeping with the traditional
representation of foreign individuals as
the mysterious "other." This image looks
ahead to the work of Roger Fenton,
who in the 1850s made Oriental studies.

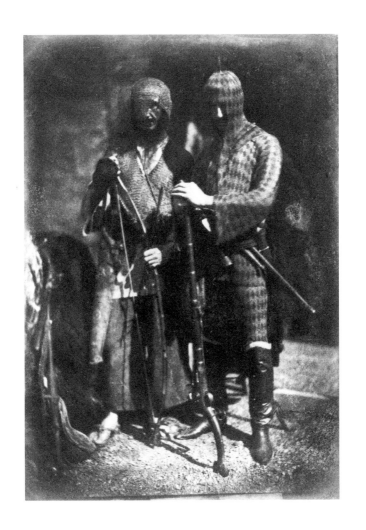

PLATE 7

Charles Sobieski Stuart

1843

Salt print
14 × 19.7 cm
84.XO.734.4.3.27

The fascination for exotic costumes, exemplified by *Afghans* (pl. 6), did not always involve far-off lands. The nineteenth century saw a renewed interest in the Highland dress of Scotland. Two men who held themselves to be experts in the field of kilts and tartans were Charles Sobieski Stuart (1799?–1880) and his brother John (1795?–1872). The siblings arrived in Edinburgh from the Continent around 1818, claiming to be descendants of Prince Charles Edward Stuart (1720–88). After the prince's defeat in the Jacobite rebellion of 1745, Highland dress was banned from 1746 to 1782. By the end of the eighteenth century, however, tartan was found in the military uniforms of many Highland regiments (see pls. 8–9). Its popularity increased with the romantic writings of Sir Walter Scott (1771–1832), who was partial to wearing Highland dress and encouraged King George IV to do likewise upon his state visit to Edinburgh in 1822, effectively giving it the royal seal of approval.

The intriguing figure of Charles Sobieski Stuart is presented in an appropriately fanciful manner. He is shown reclining along a rock wall, dressed in the very apparel of which he claimed expertise. In 1844 Hill and Adamson exhibited a print of Stuart at the Royal Scottish Academy.

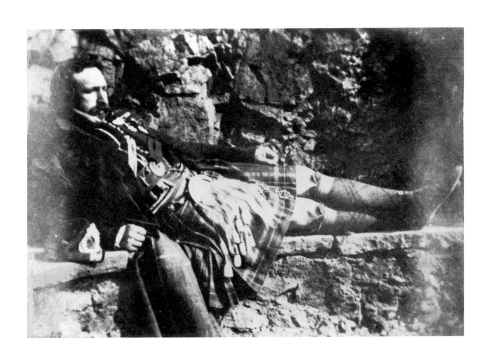

PLATE 8

The 92nd Gordon Highlanders

April 1846

Waxed paper negative
14.8 × 19.9 cm
84.XM.445.3

PLATE 9

The 92nd Gordon Highlanders

April 1846

Salt print
14.5 × 19.6 cm
84.XM.445.18

These two plates allow a comparison of the paper negative and positive print of the same image. To make a calotype, high-quality writing paper (Hill and Adamson favored the Whatman Turkey Mill brand) was first coated with a solution of silver nitrate. After drying, the paper was treated with potassium iodide. Before exposure, a mixture of acetic and gallic acids and silver nitrate was applied. The image caught on the resulting negative was latent, therefore requiring development with additional silver nitrate and acetic and gallic acids. Once this was completed, the negative was placed on top of a second sheet of treated paper, and both were left in direct sunlight. This form of contact printing meant that the print size correlated to that of the negative. Waxing the negative increased its transparency and strengthened the durability of the paper. Many critics likened calotypes to engravings and mezzotints, because the image soaked into the paper fibers, causing a slightly blurred, painterly effect. The marine painter Clarkson Stanfield (1793–1867), upon receiving an album of Hill and Adamson's works in 1845, declared that he "would rather have a set of them than the finest Rembrandts."

The 92nd Gordon Highlanders were stationed at Edinburgh Castle from July 1845 until August 1846. Hill used some of the calotypes of the soldiers as studies for his 1847 painting *Edinburgh from the Castle* (National Gallery of Scotland).

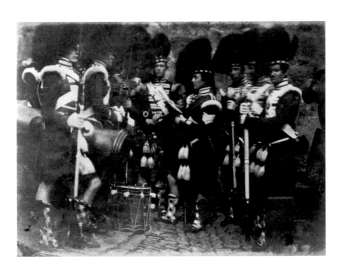

PLATE 10

Professor Spence

July 8, 1844

Salt print
20.3 × 14.4 cm
84.XO.734.4.2.10

This rather somber-looking gentleman, referred to by his students as "Dismal Jimmy," is James Spence (1812–82), professor of surgery at Edinburgh University. He sat for Hill and Adamson on various occasions in June and July of 1844. The dark mood of this photograph is heightened by the presence of the human skull; its wide, toothy grin is ironically juxtaposed with Spence's dour expression.

In the spring of 1844 Hill had moved in with Adamson at Rock House, situated high above Edinburgh with a panoramic view of the city. Their photographic studio was set up in the backyard, where there was strong natural light, an essential element in the calotype process. Various props were employed in this exterior studio to facilitate the look of an interior environment and, on occasion, to provide a subtle indication of the sitter's occupation. In this image the large drape in the background and the table suggest a room within the house, while the skull relates to Spence's knowledge of human anatomy.

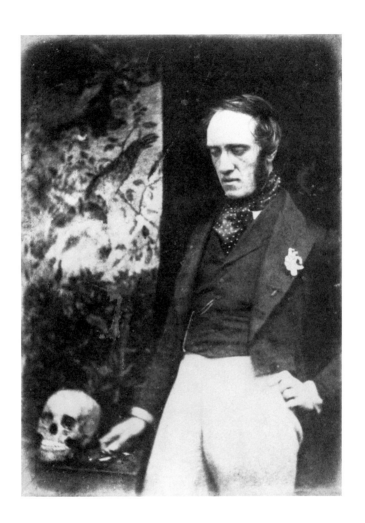

PLATE II

John Stevens, R.S.A.

Circa 1844–45

Salt print
19.8 × 14.8 cm
84.XO.734.4.2.17

John Stevens (circa 1793–1868), a member of the Royal Scottish Academy, was both a painter and a sculptor. As if to indicate his double career, he is posed here holding a paintbrush and standing beside one of his sculptures, a large bust known as *The Last of the Romans* (see also pl. 43). Hill and Adamson exhibited a calotype of Stevens at the Academy in 1845, along with nine other portraits.

The photographers had exhibited work at the Edinburgh gallery owned by Alexander Hill as early as July 1843. They first showed their calotypes at the Royal Scottish Academy in 1844. That same year, examples could be seen at Mr. Grundy's Repository of the Arts in Liverpool and even as far afield as the Académie des Sciences in Paris. Clearly Hill and Adamson had serious intentions of marketing their work; Hill sent prints to Dominic Colnaghi, a London dealer, early in 1845, and to John Murray, a London publisher, in 1846. In spite of these efforts, the artists achieved little commercial success.

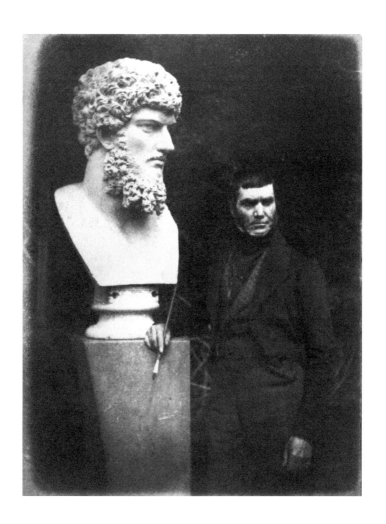

PLATE 12

James Nasmyth

1843–47

Salt print
19.7 × 14.4 cm
84.XO.734.4.1.37

The most common associational object used by Hill and Adamson to convey information pertaining to a sitter's background was a book. While such miscellaneous items as a human skull and a birdcage appear in some of the pictures (see pls. 10, 32), a book was included in many calotypes to indicate that the subject was an educated person. Held by the sitter, a book also functioned as a device to keep hands from fidgeting, while open pages often reflected light, illuminating facial features (see pl. 1). In this portrait of the inventor James Nasmyth (1808–90), the large, weighty tome is suggestive of the man's intellectual abilities, while the calipers subtly refer to his training as an engineer.

Hill had studied under Nasmyth's father, the noted landscape painter Alexander Nasmyth (1758–1840). In his autobiography James described Hill as "all in all, a most agreeable friend and companion." Hill combined a "lively sense of humour, . . . a romantic and poetic constitution of mind, and his fine sense of the beautiful in Nature."

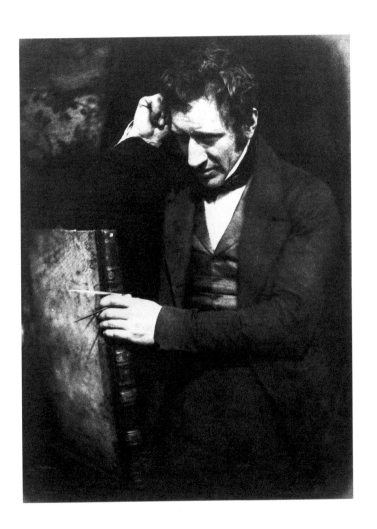

PLATE 13

D. O. Hill

1843–47

Salt print
19.3 × 13.7 cm
84.XO.734.4.3.41

In the numerous portraits made by Hill and Adamson, Hill is by far the most popular subject. He appears in more than forty calotypes, often as part of a group arrangement. Photography provided him with the opportunity to quickly explore new positioning and lighting; placing himself in front of the camera expedited these experiments. In this image he stands against the doorway of Rock House, perfectly at ease and completely composed.

Hill clearly saw his role in the partnership as providing artistic direction. Regarding the technical side of photography, he confessed in a letter of March 12, 1845, to his friend and fellow artist David Roberts (1796–1864), "I know not the process though it is done under my nose continually and I believe I never will." Adamson, concerned more with the chemical and technical aspects of the medium, occupied a behind-the-scenes role and, as a result, appears in very few photographs.

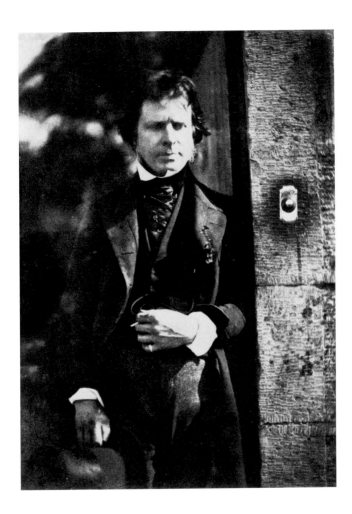

PLATE 14

The High Street, Edinburgh, with John Knox's House

Circa 1844

Salt print
14.8 × 20.1 cm
84.XO.964.14

In this image Hill and Adamson have taken their photographic equipment to the streets of Edinburgh to document the architecture of Scotland's capital city. The High Street, once the main thoroughfare, connects the historic Edinburgh Castle to the Palace of Holyroodhouse, with Parliament House and St. Giles' Cathedral situated along its cobblestones. The special point of interest in this picture is the old townhouse jutting out at left center. Built about 1490, it is largely unchanged today. The house was once home to James Mossman, goldsmith to Mary Queen of Scots, but arguably its most famous occupant was John Knox.

There was contemporary interest in Knox's house at the time Hill and Adamson took this photograph. He was invoked as a spiritual leader by the dissenting ministers caught up in the religious dispute of the 1840s. Not only was there a threat to the independence of the church, however, there was also a rupture in the rubric of Scottish society. Scotland was undergoing fundamental changes in the nineteenth century; the growing industrial and agricultural revolutions brought more people to urban areas in search of work. Many cities were unable to offer adequate housing, and certain locations quickly degenerated into slums, introducing additional social problems. Some people hoped that returning to a more spiritual way of life would alleviate these difficulties.

Normally the black, irregular border surrounding the image would be trimmed to create the finished print. However, this example and pls. 15–16 show the full sheet.

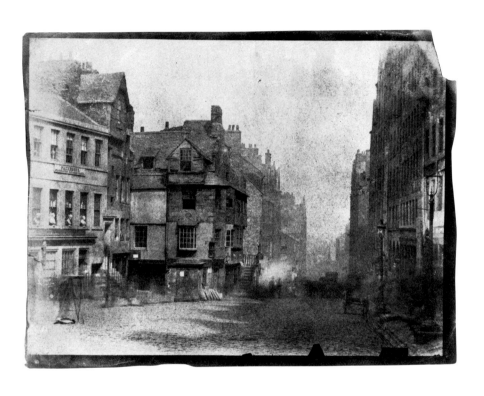

Described in *Chambers Edinburgh Journal* of 1836 as "the Westminster Abbey of Scotland," Greyfriars Kirk dates from 1620 and was the first church to be built in the capital city after the Reformation. In 1638 the National Covenant, a declaration of the Presbyterian faith, was signed there. Its churchyard is the oldest cemetery in Edinburgh.

Plate 15 shows two figures standing against a sloping backdrop of tombstones with a view of Edinburgh Castle in the distance. The fortress, situated on a volcanic crag, was home to Scottish monarchs until James VI of Scotland succeeded Elizabeth I of England as James I of England in 1603, thus uniting the two crowns. In plate 16 the panoramic backdrop of the castle is replaced with a myriad of tenement buildings in

the Old Town. The almost decorative quality of the architecture conveys a sense of the medieval city, densely organized around narrow closes and wynds. Plate 17 focuses on the Dennistoun Monument, the grave of Sir Robert Dennistoun. Hill is shown with his nieces, the Misses Watson. This image appeared on the title page of a series of large presentation albums the artist prepared with Adamson. These albums, containing approximately one hundred photographs apiece, were given away to various friends and colleagues. There are believed to be at least ten still in existence.

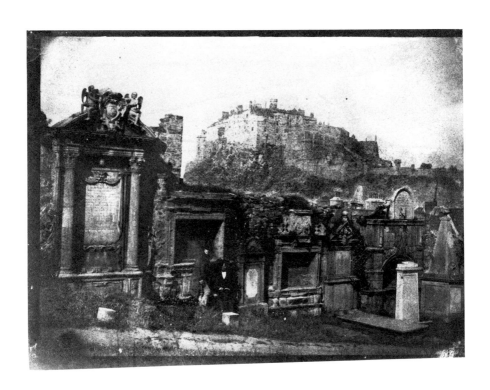

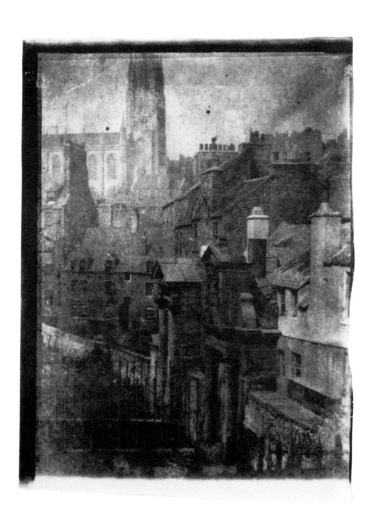

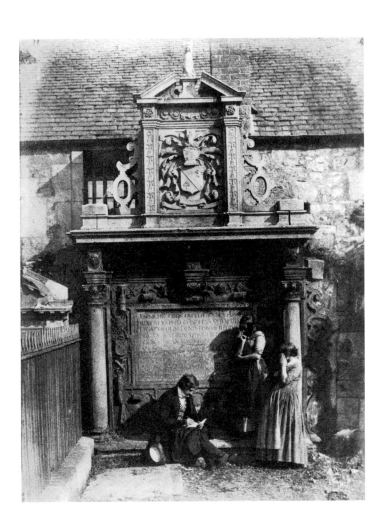

PLATE 18

Greyfriars Churchyard and Heriot's Hospital

1843–47

Salt print
14.7 × 19.7 cm
84.XO.734.4.4.44

Greyfriars Kirk proved to be a popular location for Hill and Adamson; they made more than forty exposures within the confines of the churchyard. The picturesque quality of the tombstones and memorial statuary was an obvious attraction for the photographers. Heriot's Hospital, shown in the background on the right, was founded by George Heriot, goldsmith to James VI, as a home for poor boys.

In this particular calotype the figures of two men are bent over a large camera, apparently preparing to photograph one of the grave markers (see detail on back jacket). Their identities are not known, but it is likely that the person on the left is Hill. The kneeling individual is perhaps Robert Adamson or an assistant. There was, of course, a second camera and another operator that made the negative for this print.

Hill and Adamson did employ at least one assistant, a Miss Mann, of whom little is known. It is reasonable to assume that they probably had other people working for them, considering the huge output of consistently fine images. Given that the photographers were only able to work outdoors for part of the year, the operation was extremely productive, yielding thousands of prints within the short space of four and a half years.

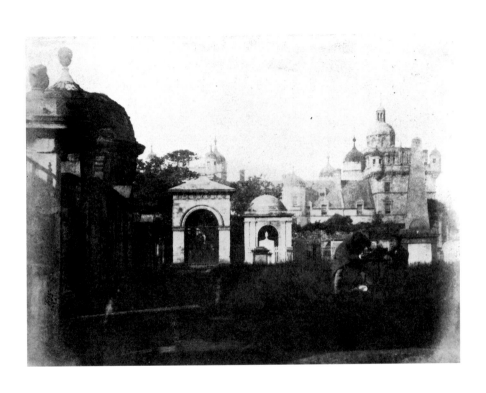

PLATE 19

Calton Hill, the Dugald Stewart Monument

1843–47

Salt print
21.5 × 26.9 cm
84.XP.368.5

Rock House, situated on Calton Hill, over-looked an area of Edinburgh known as the New Town. In the mid-1700s plans were drawn up to develop the land to the north, because the city had long outgrown its original medieval boundaries. In contrast to the Old Town's overcrowded layout, the New Town was organized around a spacious grid designed in 1767 by the young architect James Craig (1744–95).

Edinburgh became known as the "Athens of the North" during the early years of the nineteenth century due to the Neo-classical designs of the architect William Henry Playfair (1789–1857), who built two memorials on Calton Hill. The National Monument, the largest structure on the hill, commemorates the Napoleonic Wars. A reproduction of the Parthenon, it was begun in 1822 and remains unfinished. This calotype shows the second memorial, a smaller, circular temple dedicated to the great Scottish philosopher Dugald Stewart (1753–1828), who was a leading figure during the Enlightenment.

In 1792 Stewart published *Elements of the Philosophy of the Human Mind,* a treatise that begins with a discussion on sight. Stewart, like the philosopher David Hume (1711–76) before him, was particularly interested in perception as a means of understanding the world, believing that one could not focus on everything but was limited to specific details. A visual illustra-tion of this discourse was found in portrait paintings by Allan Ramsay (1713–84) and Sir Henry Raeburn (1756–1823), where the focus was on the face and less on the surroundings, which were often rendered in cursory brush strokes. Such associations between philosophy and art were quite profound in Scotland. When photography was introduced, its relationship to these sight and perception ideas was surely com-prehensible to many. Thus the calotypes of Hill and Adamson not only continued in the tradition of portraiture, they also touched on the philosophical concerns of the late eighteenth century.

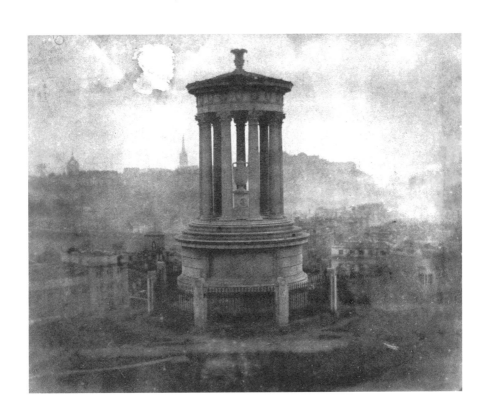

PLATE 20

Scott Monument, Edinburgh

1844

Salt print
20 × 15 cm
84.XO.734.4.4.2

The Scott Monument, designed by the architect George Meikle Kemp (1795–1844), was erected on Edinburgh's Princes Street in honor of the great Scottish author. Scott's works, especially his thirty-two Waverley Novels, were immensely popular across Europe. A lot of his early writings were based on events in Scottish history; to a certain extent Scotland's national identity was shaped by his romantic stories.

Early in 1844 a series of social events known as the Waverley Balls began taking place. Featuring tableaux vivants that included scenes from Scott's poetry and fiction (see pl. 25), the affairs were intended to raise money for the statuary on the monument. In this photograph Hill and Adamson capture the edifice while it is still under construction. Just visible on the horizon are some of the memorials on Calton Hill, including the Neoclassical temple dedicated to Dugald Stewart (pl. 19).

Talbot traveled to Scotland in October 1844 in order to make calotypes for his album *Sun Pictures in Scotland* (1845). One of the twenty-three plates showed the Scott Monument nearing completion (p. 119). The finished structure, dedicated in 1846, has a two-hundred-foot spire that overlooks both the Old and New Towns of Edinburgh.

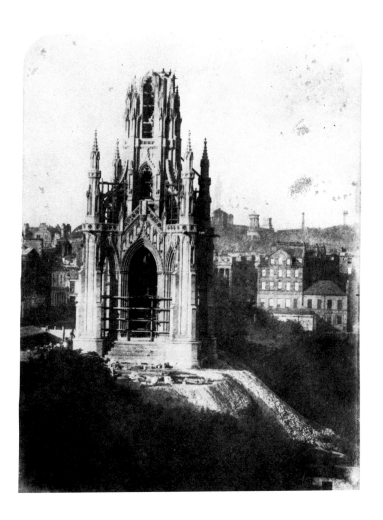

PLATE 21

Durham Cathedral

September/October 1844

Salt print
29.2 × 37.4 cm
84.XP.368.8

Prior to Talbot's visit to Scotland in the fall of 1844, Hill and Adamson traveled to York, England, for the annual meeting of the British Association for the Advancement of Science. The organization, founded in 1829 (Brewster was one of its original members), held these meetings as a forum for the exchange of information about the latest scientific developments. Before making the trip at the end of September, Hill and Adamson had to request permission from Talbot to work in England. After developing the calotype in 1840, he had quickly patented the process, thereby restricting its use to those photographers who sought and gained his approval. On the suggestion of Brewster, Talbot had refrained from extending his patent to Scotland, meaning Hill and Adamson were able to work there freely. Talbot granted permission for the two Scotsmen to make photographs at the York meeting, perhaps because he was aware that he would be working in Scotland in the very near future.

Once in York, Hill and Adamson created calotypes of most of the participants as well as pictures of some of the surrounding architecture, including this impressive view of nearby Durham Cathedral. The image was made with a large-format camera, acquired in the spring of 1844 from Thomas Davidson, an optician in Edinburgh who specialized in photographic equipment. The camera measured two feet square and was used primarily to make architectural studies, as the increased size meant an increase in exposure time. The bigger camera was evidently not practical, however; most of Hill and Adamson's prints are from smaller devices.

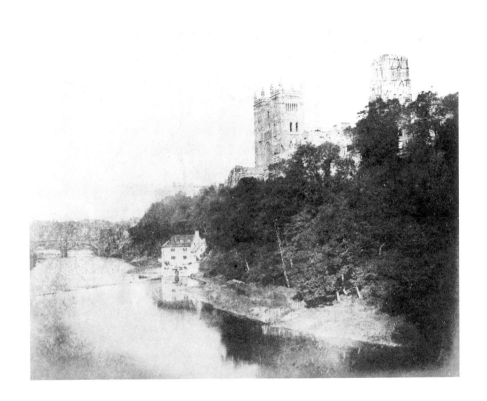

PLATE 22

Miss Elizabeth Rigby

Circa 1844–45

Salt print
20.9 × 15.9 cm
84.XP.460.7

Elizabeth Rigby (1809–93) lived in Edinburgh during the 1840s, where she was welcomed into distinguished literary and social circles. She became a very popular sitter for Hill and Adamson, appearing in more than twenty calotypes. One of these is believed to have been the first photograph viewed by Prince Albert. In this image she seems lost in thought. Although leaning forward, she does not engage the viewer. The common motif of books alludes to her intellectual abilities.

In 1849 Rigby assumed the title Lady Eastlake upon marrying Sir Charles Eastlake (1793–1865), who in 1853 became the first president of the Royal Photographic Society in London. A regular contributor to the *Quarterly Review*, she singled out Hill and Adamson's work in an 1857 article: "Photography made but slow way in England; and the first knowledge to many even of her existence came back to us from across the Border. It was in Edinburgh where the first earnest, professional practice of the art began, and the calotypes of Messrs. Hill and Adamson remain to this day the most picturesque specimens of the new discovery."

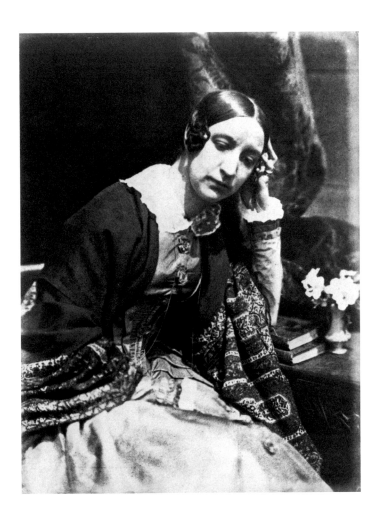

PLATE 23

Mrs. Anne
(Palgrave) Rigby

1843–47

Salt print
20.1 × 14.8 cm
84.XM.131.13

Mrs. Anne Rigby (1777–1872) moved to Edinburgh from Norfolk, England, in 1842, accompanied by her daughters Matilda and Elizabeth (pl. 22). Described by one relative as "a bright, clever, energetic woman," Mrs. Rigby "was a strict disciplinarian as to punctuality" who "never allowed her children to have 'nerves.'" The severity of this portrait, taken in profile by Hill and Adamson, emphasizes her strong character. The white, lace pelerine is contrasted with the dark dress, whose leaf pattern echoes the blurred foliage in the background.

This photograph anticipates and may even have influenced the iconic painting *Arrangement in Grey and Black: Portrait of the Painter's Mother* (1871; Musée d'Orsay) by James Abbott McNeill Whistler (1834–1903). The American expatriate visited Edinburgh in July 1849 and, having connections with both Sir William Allan (pl. 5) and the Rigbys, may have had the opportunity to view Hill and Adamson's calotypes. It is known that in May 1893, more than twenty years after the completion of the painting, the Secessionist photographer James Craig Annan (1864–1946) sent copies of some of Hill and Adamson's pictures to Whistler, who was dutifully impressed with their work.

PLATE 24

George Combe

1843–47

Salt print
19.5 × 14 cm
84.XO.734.4.2.14

In the late 1700s and early 1800s Edinburgh became an important center for research into the treatment of mental illness, which in turn led to studies in psychiatry and phrenology. The latter discipline taught that the shape of a person's skull revealed his or her intelligence and character. George Combe (1788–1858) became a leading practitioner of this immensely popular nineteenth-century "science." In 1817 he traveled to Paris to study the phrenological hypothesis of Franz Joseph Gall (1758–1828); in the 1820s he published *Elements of Phrenology* and *The Constitution of Man.*

In a journal entry of November 5, 1842, Elizabeth Rigby records meeting Combe at a dinner party, noting that he has "a good forehead in attestation of his intellect, and a hard face in betrayal of his morals."

In this photograph he is seated at an angle, perhaps positioned by Hill and Adamson to highlight his cranial form.

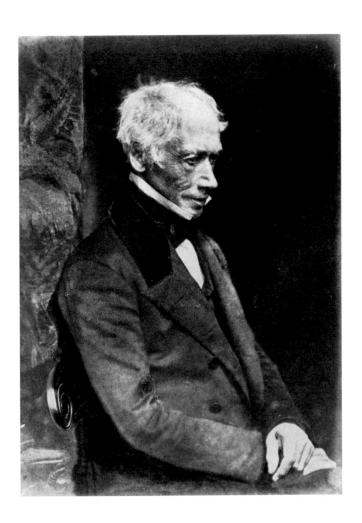

PLATE 25

Byrne, the
Blind Irish Harper
April 1845

Salt print
20.6 × 15.5 cm
84.XO.734.4.3.17

Patrick Byrne (1797?–1863), although blind, was a highly skilled harpist from Ireland. In April 1845 he performed in Edinburgh at one of the Waverley Balls, appearing in a tableau based on Sir Walter Scott's full-length narrative poem *The Lay of the Last Minstrel* (1805).

This portrait of Byrne, taken at Rock House, shows him as the central figure in Scott's poem. He is seated with his harp, swathed in blankets, and wearing a wreath on his head. Extra props are visible in the image—a metal helmet on the floor and a glass and pitcher on the corner of the table—but the main focus is on Byrne, specifically his face and hands. The curious light on his countenance appears to empha-size his eyes, while the bold, striped markings on his "robe" direct attention to

his right arm. The sunlight, which seems to be coming from the right side, is so strong that even the ornate markings on the harp can be seen. The photograph captures Scott's description of the musician:

The way was long, the wind was cold,
The Minstrel was infirm and old;
His withered cheek, and tresses gray,
Seemed to have known a better day.

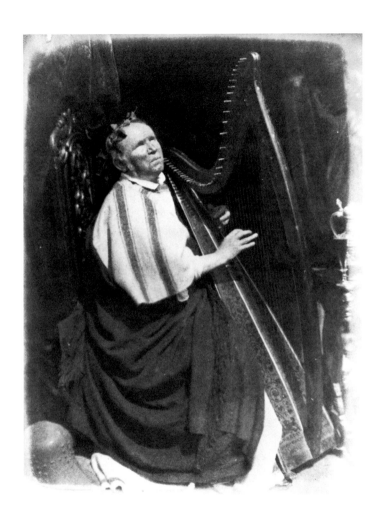

PLATE 26

Finlay, Deerstalker

April 17, 1845

Salt print
28.2 × 22.6 cm
84.XP.368.3

Finlay, a deerstalker for the Scottish folk-lorist John Campbell of Islay (1822–85), was responsible for scouting deer for hunting expeditions. This gallant portrait shows him, resplendent in tartan, standing against a rock face. The large size of the calotype imbues the work with a heroic quality, reminiscent of Sir Henry Raeburn's painting *Colonel Alastair Ranaldson Macdonnell of Glengarry* (c. 1812; National Gallery of Scotland), where the subject emerges from a dark background.

Like the image of Charles Sobieski Stuart (pl. 7), this photograph is a romantic one, highlighting the traditional Highland costume of the kilt. While tartan and the kilt were firmly entrenched in Scottish character by Hill and Adamson's time, they were, to a certain extent, manufactured products of the seventeenth century. The modern kilt, as shown here, was adapted from the *féile-breacan,* a single piece of woolen cloth worn like a skirt and wrapped over one shoulder.

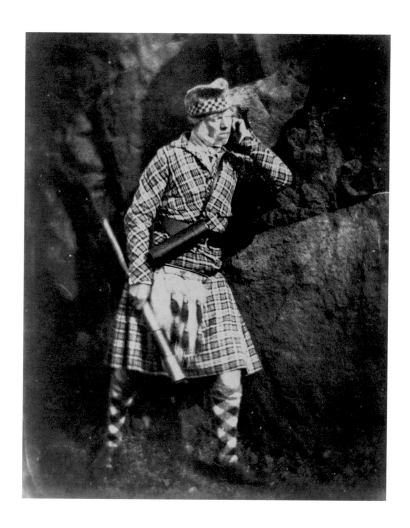

PLATE 27

Rev. Peter Jones

August 4, 1845

Salt print
21.1 × 15.3 cm
84.XO.608.16

Peter Jones (1802–56), born near Lake
Ontario in Canada, had a father of Welsh
descent and a mother who was an Ojibway
Indian. Growing up within the tribe,
he was given the name Kahkewaquonaby,
meaning "Sacred Waving Eagle's Plume."
Baptized in the Wesleyan Methodist Church
as a teenager, Jones later became a mis-
sionary to the Indians.

In July 1845 Jones preached in Edin-
burgh. Hill and Adamson made several
calotypes of him on August 4. In some of
the pictures he wears Indian garments
(as seen here); in others he is dressed in
Western clothes. These images are among
the oldest surviving photographs of a
North American Indian.

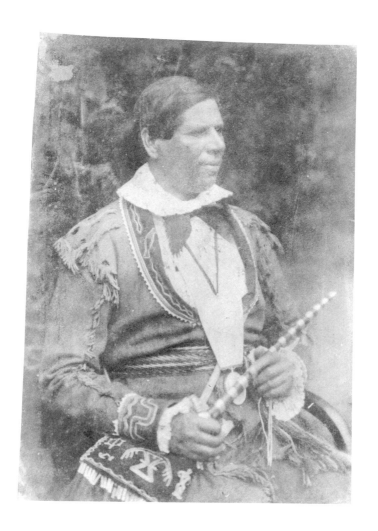

PLATE 28

Sheriff Spiers

1843–47

Salt print
19.6 × 14.1 cm
84.XO.734.4.1.15

Although Hill and Adamson advertised for sitters for the Disruption Picture until 1846, Hill's initial enthusiasm for the work waned somewhat as he became more and more involved with photography as an independent form of expression. While the partnership's choice of subject matter expanded, individuals connected with the Free Church of Scotland continued to pose in front of the camera at Rock House.

Graham Spiers (1797–1847) was sheriff of Midlothian and a leading Free Churchman. He described the dissension within the Church of Scotland as an issue of democracy. Also a prison reformer, Spiers served as a member of the General Board of Prisons in Scotland and as chairman of Edinburgh Prison.

In this calotype Spiers looks appropriately serious. He emerges from the broad, dark mass of the background, the main source of light falling on his hands, which clasp a book. The light also catches the tablecloth, whose herringbone pattern is clearly visible.

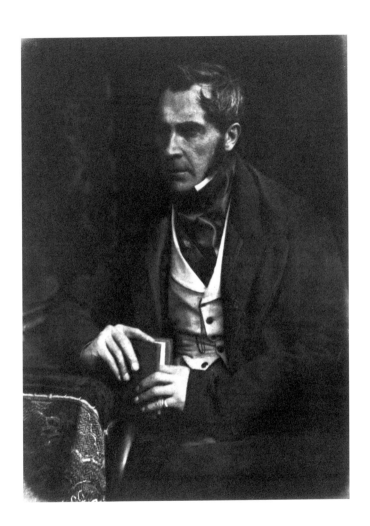

PLATE 29

Dumbarton Presbytery

March 29, 1845

Salt print
16.5 × 22.5 cm
84.XO.608.7

This group portrait shows the ministers
who belonged to the Dumbarton Presbytery
in the west of Scotland. The men are,
from left to right, Rev. William Alexander
of Duntocher (1808–90), Rev. McMillan of
Cardross (ordained 1828), Rev. James
Smith (1806–62), and Rev. John Pollok (d.
1855). The figures were transposed directly
into the Disruption Picture (they appear
under the left skylight). Compared to
the earlier group portrait featuring Brew-
ster (pl. 3), this image appears more sophis-
ticated. The subjects, contained within
a tighter composition, are all focusing on
a large book. An interesting element in
the design is the drape in the background,
which is arranged precisely in the middle
of the quartet, with the pattern of the
fabric revealing an eagle swooping down
among the men.

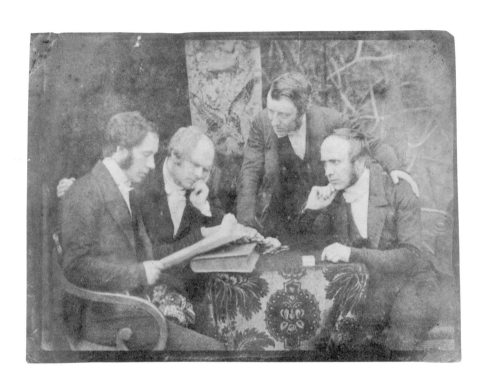

PLATE 30

Edinburgh Ale

1843–47

Salt print
14.5 × 19.7 cm
84.XO.734.4.5.18

Although similar in composition to the group portrait of Dumbarton Presbytery (pl. 29), even including the same drape in the background, this informal picture of, from left to right, James Ballantine (1808–77), Dr. George Bell (d. 1889), and Hill has the feel of a modern snapshot. Through the men's relaxed poses, faint smiles, and indirect gazes, the scene appears spontaneous, consequently possessing a vitality much different from the ministerial image. There is the impression that a small social gathering—complete with glasses of beer—has been interrupted. The men all seem to be looking off-camera, perhaps at another member of their social set.

Hill was a congenial character with many friends and colleagues whom he often invited to participate in calotype portraits. Two such associates were Ballantine, an author and stained glass artist, and Bell, a social reformer who was one of the founders of the "ragged schools," established for underprivileged children.

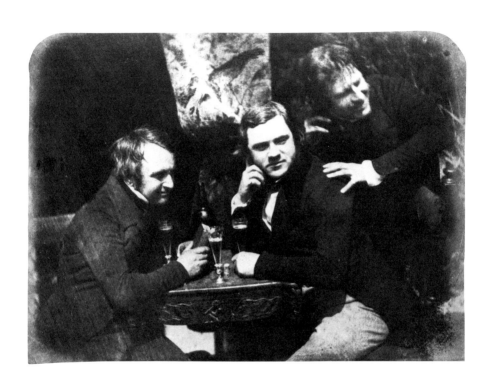

PLATE 3 I

At the Minnow Pool

1843–47

Salt print
21 × 14.8 cm
84.XM.966.12

Whether arranging ministers for the Disruption Picture or friends for an informal portrait, Hill and Adamson displayed a talent at working with groups. This ability is particularly noteworthy in this calotype of the children of the solicitor Charles Finlay (1788–1872). Arranged in a pyramidal composition, Arthur, John Hope, and Sophia sit patiently on lichen-covered stone steps fishing for minnows. Keeping the siblings still was quite an accomplishment for the photographers, who needed sitters to remain in a fixed position for the duration of the exposure, which sometimes could be as long as a couple of minutes, depending upon the lighting conditions. In spite of this, the image is not a rigid one; Hill and Adamson have successfully captured the sense of children at play. The informal poses—Sophia leaning on the top step and John Hope allowing his leg to protrude—and casual props—a dangling fishing rod and cast-off straw bonnet—convey a carefree scene.

Hill had a child of his own, a daughter named Charlotte (1839–62), who was born the very year photography was announced to the world. A second daughter died shortly after birth in 1840, followed soon after by Hill's spouse. In 1862 he married the sculptor Amelia Paton (1802–1904). Adamson, who died young, had no wife or children of his own.

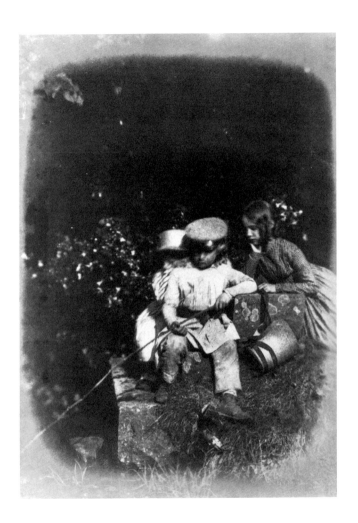

PLATE 32

Miss Ellen and
Miss Agnes Milne
1843–47

Salt print
19.5 × 14 cm
84.XM.445.6

Even the most staged works of Hill and Adamson possess a naturalism that belies the presence of the camera. The subjects of the calotypes rarely acknowledge the photographers or their equipment. Instead, the sitters often look away or focus on an object within the composition. David Bruce, in *Sun Pictures: The Hill-Adamson Calotypes* (1974), suggests that this "sense of repose" is perhaps due to the fact that the models did not know "how to present themselves . . . , if only because the experience of photography of the individuals or indeed of the community must have been extremely limited."

In this full-length portrait of Ellen and Agnes Milne, the young women turn their heads to the side, revealing their intricate hairstyles. Standing against a trellis and doorway at Rock House, a familiar back-drop (see also pls. 5, 47), the sisters are surrounded by bonnets, books, a parasol, and a birdcage, complete with a bird drawn on the negative by Hill. The bright light enables the camera to capture the patterns of the siblings' dresses and shawls.

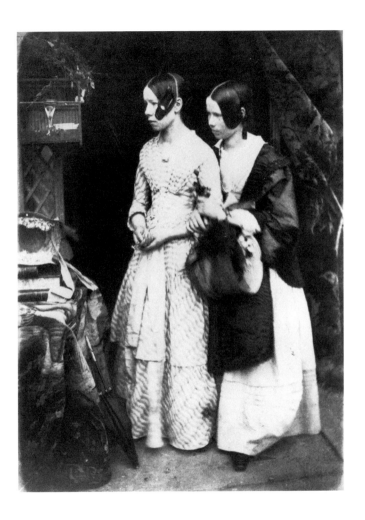

PLATE 33

James Linton

1843–47

Salt print
20.2 × 14.7 cm
84.XM.445.1

Some of Hill and Adamson's finest work features the men, women, and children of the small fishing village of Newhaven, one mile north of Edinburgh. Consisting of approximately 130 images, this group of pictures may be seen as the first social documentary photographs ever made.

There was a considerable amount of interest in Newhaven in the early nineteenth century. Set against a national backdrop of social upheaval, it appeared to represent the ideal of an independent community of great moral standing. While the heroism of the common person was a popular subject in art and literature, figuring, for example, in the paintings of Sir David Wilkie and the poetry of Robert Burns (1759–96), the fact that Newhaven was easily accessible from Edinburgh also played an

important part in Hill and Adamson's choice of subject.

This portrait of the fisherman James Linton shows him leaning against a boat in a casual position. Unable to show him at sea, the artists have skillfully surrounded Linton with the attributes of his job. The natural appearance of the people in the Newhaven pictures suggests that Hill and Adamson earned the trust and cooperation of the fisherfolk.

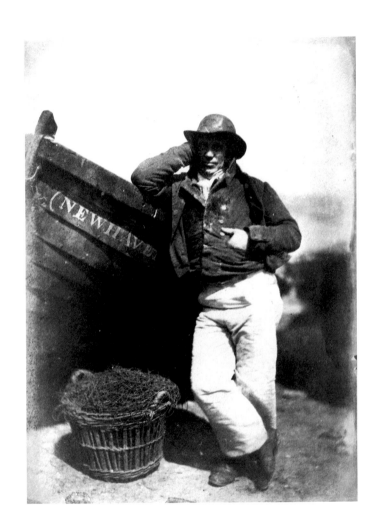

PLATE 34

Mrs. Elizabeth (Johnstone) Hall

1843–47

Salt print
19.2 × 14 cm
84.XO.734.4.5.2

The fisherwomen of Newhaven were noted for their natural beauty and picturesque costumes. Writing in her journal in August 1843, Elizabeth Rigby described one of the fishwives as "with as heavy a load of petticoats as of fish: a lovely blooming creature, with a complexion of that transparent kind of which our aristocracy are most proud. . . . She was laden with clothes, petticoat over petticoat, striped and whole colour, all of the thickest woollen material."

This intimate portrait of Mrs. Elizabeth Hall is a powerful tour de force of simplicity. She looks away from the camera and slightly down, half of her face cast in shadow. The light falls on the creel's horizontal wickerwork, which is juxtaposed with the apron's vertical stripes. Hill's later caption for the image—"A Newhaven Beauty,

'It's no fish ye're buying: it's men's lives,'" taken from Sir Walter Scott's novel *The Antiquary* (1816)—reveals not only the popularity of the fisherfolk as subjects but also a knowledge of Scott's work. The reference to the cost of the fish relating directly to men's lives bore a certain amount of truth; the powerful waves and treacherously cold waters of the North Sea made fishing a perilous job.

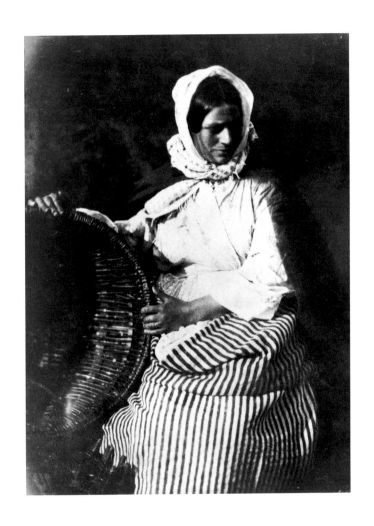

PLATE 35

The King Fisher,
Newhaven

1843–47

Salt print
19.9 × 14.5 cm
84.XM.966.8

Dutifully standing by a boat and basket of
fishing line, this boy appears to accept his
destiny of becoming a fisherman. There
is a tenderness and poignancy to the image;
Hill and Adamson contrast the size of the
child with the tools associated with his
demanding trade. While the boat and basket
are typical props, the chair was probably
employed to provide support for the lad
during the exposure.

Hill inscribed this print with the words
"His faither's breeks he hath girded on,"
alluding to the fact that the boy is wearing
clothes belonging to his father. This sug-
gests that the adult has been lost at sea and
that his son has assumed the responsibility
of fishing.

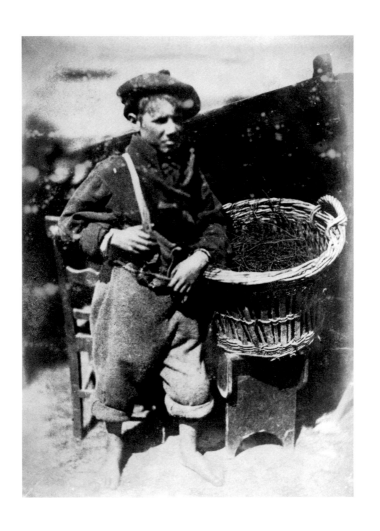

PLATE 36

The Letter

1843–47

Salt print
20.4 × 14.3 cm
84.XM.966.10

The existence of a few variants of this plate indicates that Hill and Adamson experimented with the subject on a number of occasions. The theme of *The Letter* harks back to seventeenth-century genre paintings, such as those by Vermeer. This influence did not go unnoticed—an article on Scottish fishermen in the *North British Review* in the summer of 1844 comments on the similarities between Hill and Adamson's calotypes and work by Dutch artists. The fact that the piece mentions the Newhaven prints makes it clear that the photographers had begun creating pictures of the fishing community very soon after the formation of their partnership.

In addition to the beauty of the images, the article also remarks upon their truthful qualities. This notion of truth is one that is bound up in the very mechanics of the camera, which is looked upon as an objective tool. This is, of course, an inaccurate assumption, as compositions can be contrived and negatives altered. In this print the fisherwomen—from left to right, Marion Finlay, Margaret Dryburgh Lyall, and Grace Finlay Ramsay— are posed; traces of headrests are faintly visible in the background. There is even speculation that the picture was made at Rock House and not in Newhaven. However, Hill and Adamson have succeeded in presenting a humble scene from everyday life in this seemingly genuine portrayal.

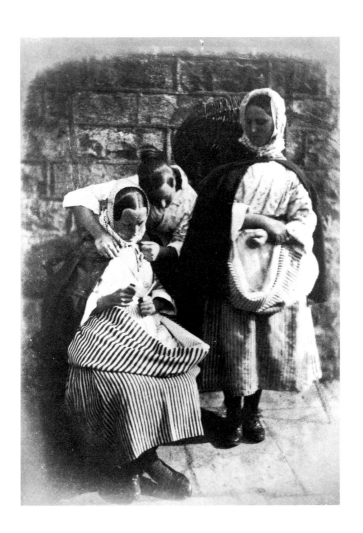

PLATE 37

Newhaven
Fishermen
1843–47

Salt print
14.1 × 19.4 cm
84.XM.445.12

It is unlikely that the people of Newhaven had seen a camera before Hill and Adamson began working in their community. This ignorance of the photographic medium meant that the fisherfolk were not predisposed to seeing themselves in any particular way. As a result, each image possesses a great degree of naturalism, despite the careful poses arranged by Hill and Adamson. In this picture eleven fishermen are casually standing on the beach, seemingly oblivious to the presence of the photographers. The top hats silhouetted against the blank sky and the white trousers contrasted with the dark clothing create a striking image.

Although one may argue that the Newhaven images are the first social documentary photographs, it is doubtful that Hill and Adamson planned to use them to any sociopolitical end. The importance of the pictures lies in the artists' recognition that they could go beyond the confines of the studio to make calotypes of live subjects in situ. The result is a series of candid prints that are both beautiful and arresting.

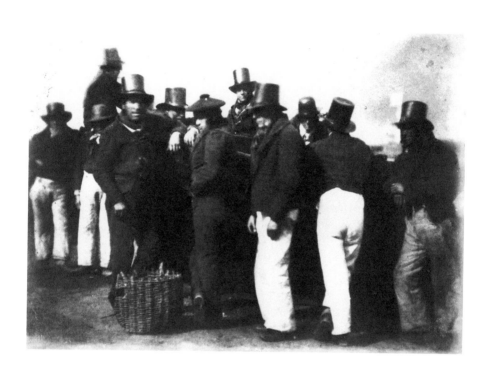

PLATE 38

St. Andrews Cathedral, the East Gable

1846

Salt print
19.5 × 14.5 cm
84.XO.965.12

Taking advantage of the fact that the calotype allowed the production of multiple prints from a single negative, Hill and Adamson drew up plans to publish their pictures in bound albums that would be available for public purchase. On August 3, 1844, they ran an advertisement in the *Edinburgh Evening Courant* stating that possible subjects for these volumes would include the inhabitants of fishing villages; Highland character and dress; the architecture of Scotland's principal cities, Edinburgh and Glasgow; historic monuments around the country; and portraits of famous Scotsmen. Strangely, none of these albums was ever realized, in spite of the group of existing Newhaven fishing photographs upon which to draw for the first volume.

In 1846, however, Hill and Adamson did publish a set of albums, which featured the town of St. Andrews (see also pls. 39–41). Each copy of *A Series of Calotype Views of St. Andrews* contained about twenty-one plates (the Getty Museum's copy has twenty-three). This plate shows the east gable of the ruins of St. Andrews Cathedral. The spires are dramatically silhouetted against the overexposed sky, a view exploited further by Hill and Adamson's choice of perspective. The dynamic composition, with the outer wall and pathway receding to the right at a gentle angle, contrasts with the simpler approach of Adamson before he entered into partnership with Hill (see p. 145).

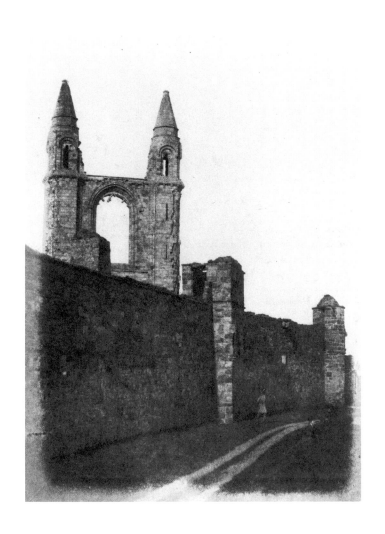

PLATE 39

**Argyle Gate,
St. Andrews**

1846

Salt print
17.5 × 14.8 cm
84.XO.965.8

The Pends, the area of St. Andrews shown
in this calotype, marks the entrance to the
cathedral district. Hill and Adamson have
positioned their camera directly in front of
an arched gateway, capturing a fascinating
play of light, shade, and form. The picture
extends backward, through and beyond
the second arch, and upward, to the small
patch of sky that is punctuated by a chim-
ney. In spite of the tension inherent in the
composition, Hill and Adamson have skill-
fully contained the image within the frame
of the arch in the foreground. The light
at the top contrasts with the shadow on the
left, which cuts across the pathway and
merges with the right wall, completing the
sense of enclosure.

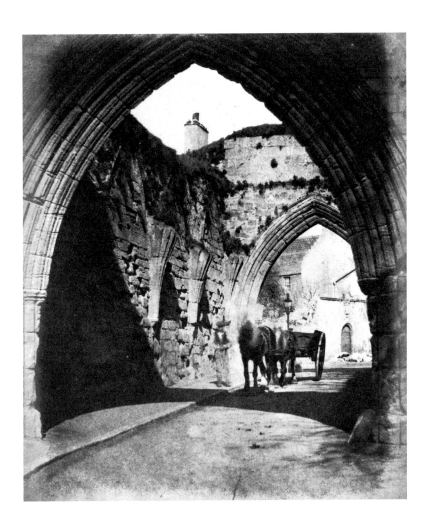

PLATE 40

St. Andrews Harbor

1846

Salt print
14.5 × 19.7 cm
84.XO.734.4.4.32

In this harbor image the St. Andrews sky-
line is punctuated by an array of vertical
shapes: towers, turrets, masts, and chimneys.
The twin medieval spires of St. Andrews
Cathedral are paired with the two spindly
spars of a ship.

The town is named for the apostle
Saint Andrew, whose bones, according to
legend, were carried there by Saint Rule
(his tower is the square monolith to the left
of the cathedral). During the Middle Ages
the city took on great religious importance
and attracted many pilgrims, making it
the ancient ecclesiastical capital of Scot-
land. In 1411 St. Andrews became home to
the country's first university. More than
four hundred years later, through the efforts
of Brewster and John Adamson, the town
earned another distinction, becoming
the birthplace of photography in Scotland.

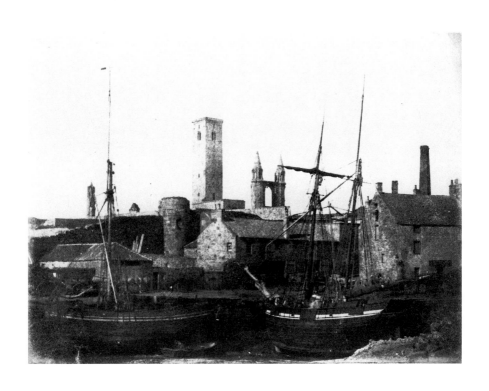

PLATE 41

Fishergate, St. Andrews

1846

Salt print
14.9 × 19.7 cm
84.XO.964.23

St. Andrews, like Newhaven, was a fishing town. This image of St. Andrews fisherfolk, however, contrasts with Hill and Adamson's Newhaven pictures. Instead of focusing on individuals, the photograph captures a street scene.

For all its spontaneity and apparent objectivity, this work is just as controlled as any other Hill and Adamson print. The figure of the woman striding across the cobblestone road suggests that a moment in time has been captured, but because any movement would have rendered her a blur, she must be standing still, holding her position (as well as her basket and child). This was quite an accomplishment, considering that the exposure time may have ranged from thirty seconds to a couple of minutes. A variant of the plate presents a somewhat different group arrangement, but the same woman is still crossing the street, suggesting that Hill and Adamson made multiple exposures to test various visual ideas.

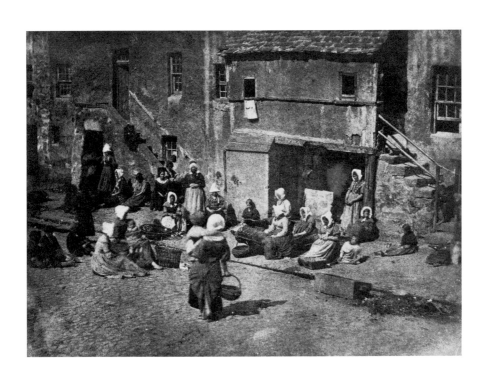

PLATE 42

John Henning and
Mrs. Elizabeth
(Cockburn) Cleghorn

1846–47

Salt print
20.6 × 15.7 cm
88.XM.57.21

In this plate the sculptor John Henning (1771–1851) and Mrs. Elizabeth Cleghorn, the daughter of the jurist Lord Cockburn (1779–1854), play the roles of Edie Ochiltree and Miss Wardour from Sir Walter Scott's *The Antiquary*. Following the text closely, Hill and Adamson have furnished Ochiltree with white hair, a staff, and a badge that indicates his beggar status. The picture illustrates this passage: "The young lady, as she presented her tall and elegant figure at the open window, but divided from the courtyard by a grating, . . . might be supposed by a romantic imagination an imprisoned damsel communicating a tale of her durance to a palmer, in order that he might call upon the gallantry of every knight whom he should meet in his wanderings to rescue her from her oppressive thraldom."

The setting for the image was Bonaly Tower, Lord Cockburn's home.

The great success of the works of Scott, who is credited as being the creator of the historical novel, possibly explains Hill and Adamson's motivation in creating tableaux vivants based on his characters (see also pl. 25). Interest in Scott would have fueled interest in their prints. In 1831 Hill had prepared illustrations for the first collected edition of Scott's Waverley Novels, but it is unclear whether the photographers planned to use their calotypes in a similar manner.

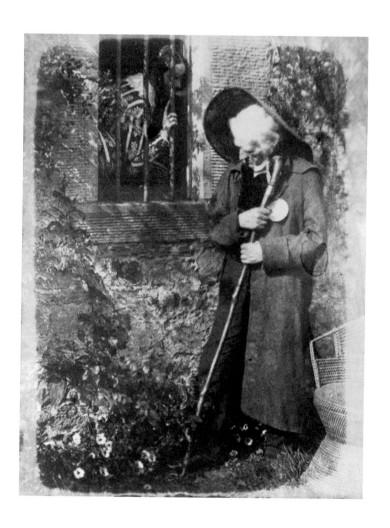

PLATE 43

The Morning After: "He, Greatly Daring, Dined"

1843–47

Salt print
20 × 14.6 cm
84.XO.734.4.5.21

Much of the success of the portraits made
by Hill and Adamson is said to be due
to Hill's convivial personality, which made
sitters feel instantly at ease. In this par-
ticular image his sense of humor comes to
the fore as he poses along with James
Miller (1812–64), professor of surgery at
Edinburgh University. The scene presents
Hill the morning after a night of indul-
gence, indicated by the distressed look on
his face. He rests his left arm on the
base of *The Last of the Romans* (see pl. 11)
while Miller checks his pulse. The title
of the photograph is a clever pun on the
inscription on Phaeton's gravestone in
Ovid's *Metamorphoses*: "He, greatly daring,
died." The inclusion of Miller is a visual
pun—he was not only a professor but also
a temperance reformer.

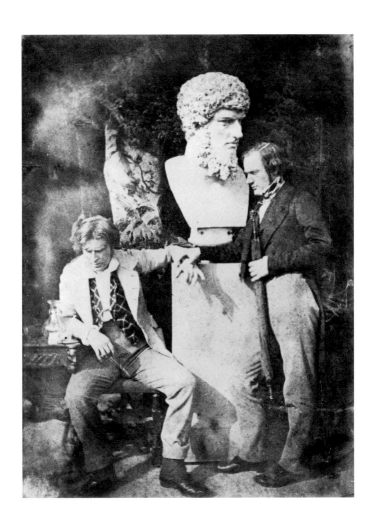

PLATE 44

Miss Elizabeth Logan

1843–47

Salt print
15 × 19.9 cm
84.XM.263.1

In this plate Hill and Adamson have avoided
the perils of photographing a fidgeting
child by having her feign sleep. Elizabeth
Logan was the daughter of Alexander
Stuart Logan (1811–62), also a portrait sub-
ject, who became the sheriff of Forfar-
shire in 1854. Set against a floral drapery,
which appears as a backdrop in much
of the Rock House work, the girl clutches
her doll and bares one foot (the missing
shoe is visible beside the basket at left). The
ivy leaves above her head expose the out-
door setting of the calotype. Hill was to
photograph Miss Logan again in 1861–62
when he entered into his partnership with
the Glasgow printer Alexander McGlashan.

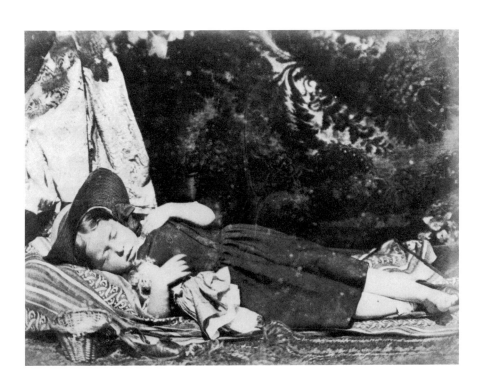

PLATE 45

David Roberts, R.A.

1843–47

Salt print
21.2 × 15.9 cm
84.XO.734.4.1.45

Hill and Adamson's photographs were the result of a successful collaboration where the partners contributed different but essential elements. A key component in their work was Adamson's technical virtuosity. In a March 12, 1845, letter to the artist David Roberts, Hill stated: "Adamson thinks he knows some things others do not." Regrettably, Hill did not elaborate. The duo's pictures, with their rich, reddish brown tones, were more uniform and permanent than Talbot's own images, suggesting that Adamson had discovered an ingredient in his development formula that improved the calotype process. Recent scientific analysis has revealed the presence of varying levels of calcium, lead, iron, and manganese in the prints but offers no conclusive evidence for their coloration.

Roberts began his artistic career as a house painter, then became a scene painter for a traveling circus. He worked for various theaters in Glasgow, Edinburgh, and London and made a number of trips to Europe, North Africa, and the Middle East, from which he drew inspiration for his topographical paintings. From 1842 to 1849 he published *Views in the Holy Land, Syria, Idumea, Arabia, Egypt and Nubia,* a six-volume series of engravings that reflected his interest in archaeological ruins.

In this full-length portrait Roberts is standing in what may be considered an archaeological site of Edinburgh: Greyfriars Churchyard. The light catches his face; his body casts a shadow against the Dennistoun Monument in the background (see pl. 17). The overturned top hat, a curious element, lies on the ground, its white label visible within the darkened mass.

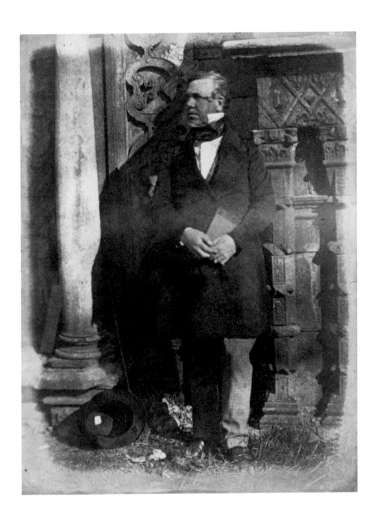

PLATE 46

Colinton Wood

1843–47

Salt print
19 × 15.2 cm
84.XM.966.9

A photograph of trees and a wooden fence, this calotype appears to be a slight departure for Hill and Adamson, in the sense that the image is a landscape and almost abstract. The fence posts, trunks, and branches produce a network of dark forms set against the light, blurred background of the foliage. The picture fades around the edges, almost like a vignette. The soft focus and lack of detail—further enhanced by the paper fibers of the print—create an impression, rather than a copy, of nature.

While the paintings of the French Impressionists were not to come for several decades, the prints of French photographers did bear relation to those of Hill and Adamson. Aware that the greatest competition regarding artistry came from France (and curiously not England, the home of paper photography), Hill expressed in a March 14, 1845, letter to Roberts a desire to produce images that "would earn more solid applause than the livid pictures of Daguerre [1789–1851]." This plate anticipates the work of Gustave Le Gray (1820–82), who in 1849 began making photographs in the Forest of Fontainebleau.

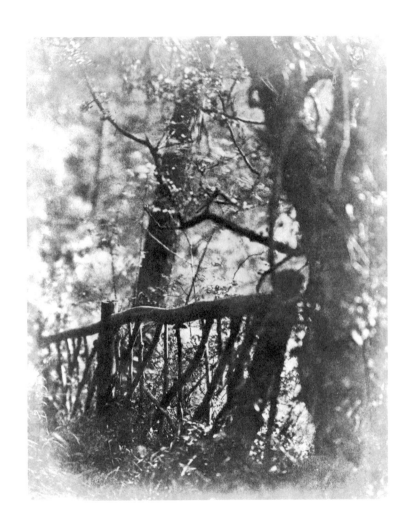

PLATE 47

Lady Mary Hamilton
(Campbell) Ruthven

Circa 1890 photogravure
from an 1847 salt print
20.1 × 14.9 cm
84.XM.445.11

This sensuous image of Lady Ruthven (1789–1885) is one of Hill and Adamson's finest portraits. Standing with her back to the camera, her head slightly turned to the side to reveal the nape of her neck, she is reminiscent of women in paintings by Jean-Auguste-Dominique Ingres (1780–1867). Hill and Adamson have skillfully contrasted areas of light and shade—the bonnet is set against the dark background, the lace shawl is delicately contrasted with the dress. The attention given to the apparel recalls fashion plates popular during the nineteenth century.

The original print of this image dates from 1847 and was one of the last that Hill and Adamson made together. In a letter Hill wrote to Lady Ruthven in late December of that year, he seems disillusioned and near to giving up photography. Sadly, the partnership did come to an end shortly thereafter when Robert Adamson died, most likely of tuberculosis.

In 1905 Alfred Stieglitz (1864–1946) published in *Camera Work*, the journal of the Photo-Secessionist movement, photogravures by James Craig Annan of Hill and Adamson's calotypes. Annan, who had begun making finely crafted copies of the duo's work in the 1890s, recognized and appreciated the beauty of the early pictures. He singled out Hill as the creative force behind the photographs, effectively reducing Adamson's role within the alliance. Nevertheless, Annan's efforts served to introduce the work of these two nineteeth-century pioneers to a twentieth-century audience.

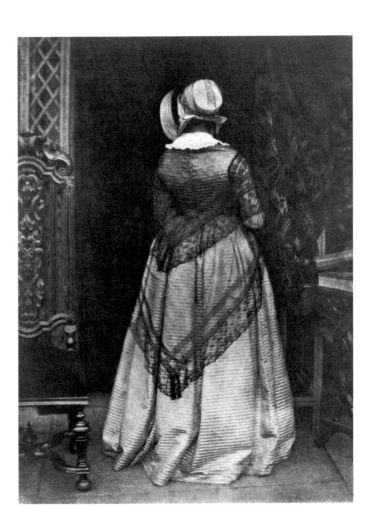

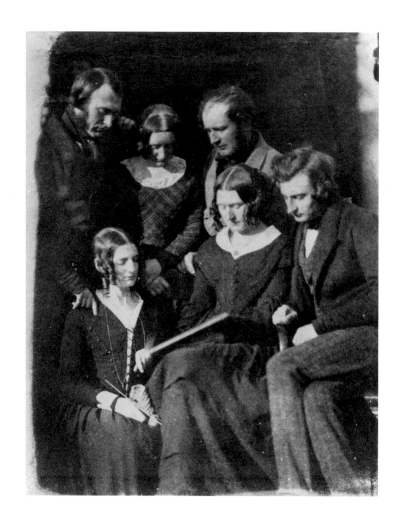

David Octavius Hill and Robert Adamson.
The Adamson Family, 1843–47. Salt print, 20.8 × 15.7 cm.
Scottish National Portrait Gallery.

A Pictorial Partnership:
The Photographs of Hill and Adamson

David Featherstone: Sara, to begin our discussion, will you give us a brief biographical sketch of David Octavius Hill and Robert Adamson and the background of their work together?

Sara Stevenson: Yes. Hill was born in 1802, the son of Thomas Hill, a bookseller in Perth, which is north of Edinburgh. He was educated at Perth Academy, a school that not only taught the classics and conventional subjects but also mathematics, chemistry, and physics to a very high standard.

Hill was one of the first people in Britain to take up the newly developed process of lithography; at the age of eighteen he published a series of lithographs. He probably moved to Edinburgh to study with the landscape painter Andrew Wilson in the School of Design there, and then he embarked on a career as a landscape and genre painter. At this point he joined the circle around Alexander Nasmyth, another landscape painter, a group of engineers, geologists, physicists, architects, and artists who, in a very sociable, relaxed, and informal way, discussed and exchanged information. Sir David Brewster was also a member of this set.

In the 1830s Hill was particularly involved in book illustration. He prepared pictures for an 1831 edition of Sir Walter Scott's works, produced a set of lithographs for a railway prospectus in 1832, and in 1834 began a series of sixty-one landscape paintings for a grand two-volume work based on Robert Burns's writings.

Hill was one of the earliest members of the Royal Scottish Academy; in 1830 he became its secretary, a post he held for forty years. In 1836 he was paid a salary and could afford to marry. Ann Macdonald, a musician and the daughter of a wine merchant, became his wife in 1837. They had two girls, one of whom survived. Ann became an invalid and died in 1840, leaving Hill a widower with a single child, Charlotte.

DF: So Hill didn't meet Adamson until after this major transition in his life.

SS: That's right. Robert Adamson was born in 1821, the son of a tenant farmer from Burnside, in Fife, near St. Andrews. Adamson was training to be an engineer, but he abandoned his apprenticeship because of poor health. He then became involved in the early photographic experiments that were happening in St. Andrews. It was Brewster who suggested that he move to Edinburgh and become the first professional photographer there using William Henry Fox Talbot's calotype process. Adamson arrived on May 10, 1843, and set up a studio in Rock House, three hundred feet above sea level on Calton Hill, overlooking Princes Street, the principal street in Edinburgh.

We don't know what he did in those first few weeks, but Brewster brought Hill up to see him at some point before June 9. Both Brewster and Hill were closely involved in the schism within the Church of Scotland, and Hill was intending to make a great painting to celebrate the founding of the Free Church of Scotland. Within a couple of weeks his view of the possibilities of photography had been revolutionized. He first thought of the medium very skeptically but then realized he could use it to make portrait photographs as sketches for the Disruption Picture.

DF: That painting is so intrinsic to Hill and Adamson's photographs that it would facilitate our discussion to have a brief description of the circumstances that brought it about.

Anne M. Lyden: In the reformed Church of Scotland, which split from Catholicism in the sixteenth century, each congregation had the right to choose its own ministers, but this right was removed in 1834 with the Veto Act. Many people resented the fact that the state had the power to intervene in spiritual matters. The growing dissension culminated on May 18, 1843, when about 150 ministers walked out of

the General Assembly in Edinburgh to establish the Free Church of Scotland. In the end, almost 500 clergymen broke away from the existing church, leaving behind their incomes, homes, and parishes. Hill was so moved by the event that he decided to commemorate the occasion with a large historical painting of the first General Assembly of the Free Church. He began it just a few weeks before he was introduced to Robert Adamson, but twenty-three years passed before its completion.

SS: On July 3, 1843, Brewster announced in a letter to Talbot that Hill and Adamson were about to enter into a partnership. Hill had just started the Disruption Picture in May; by the beginning of July he had been distracted into taking on photography. By July 8 the two men were holding their first exhibition of sketches and photographs for the painting.

Photography was done on a seasonal basis because there was not enough natural light during the winter months that far north. When work started again in April 1844, the partnership clearly became more vigorous. Hill moved into Rock House in order to work more closely with Adamson; they commissioned a large camera, which was about two feet square; and they announced that they were going to publish six volumes of photographs.

Remarkably, in 1846 Hill was still advertising for sitters for the Disruption Picture. By that time he had enlarged the scale of the painting to two to three times the size of his original plan. After June 7, 1846, there is a sudden stop in the flow of dated images. It is possible that the bulk of Hill and Adamson's work had been made by that time, since there are only two photography sessions known after June 7. In December 1847 Adamson returned home to Fife, dying there in January 1848, thus ending the partnership.

Weston Naef: Let me add a note of historical context about how soon these events occurred after the discovery of photography. About two and a half years after Talbot's announcement in January 1839, the extraordinary scientists in Scotland, whose work was fostered by a favorable climate for investigation and experimentation, were able to copy his procedure. A map of early photography would show England for Talbot and France for Daguerre, but the third place where the earliest photographs were made was Scotland. Brewster was the person who most helped in the reinvention of the calotype process there. His good friend John Adamson

was one of the most dedicated early experimenters, and John Adamson's youngest brother, Robert, was the instrument by which this new art came to be joined in the partnership with Hill.

A. D. Morrison-Low: It was specifically in St. Andrews where this early interest in the calotype took place. Brewster was in communication with Talbot and was his principal supporter in Scotland. In Edinburgh, experimentation was concerned with the daguerreotype and Mungo Ponton's silverless process.

DF: We'll begin our consideration of a series of photographs made by Hill and Adamson by looking at a portrait of each man.

WN: Viewing the image of Hill standing in the doorway of the studio (pl. 13), it's clear that several unique properties of photography can be observed. One is the way in which the polished brass doorbell and the stone wall against which he's leaning are described, another is the capturing of the texture of his clothing and the literal character of his face. In this picture, which is a richly preserved, deep reddish brown calotype, we see a wonderful resemblance of a man who projects a very masculine, handsome visage.

The photograph of Adamson (p. 7) is curiously the exact opposite. He is clearly a much slighter person. His features are very delicate. Not only is he a different physical type, one would also judge him to be a different personality type.

Let's talk about the possibility that it was Adamson who framed the portrait of Hill, where the stone is so pointedly brought to bear as a compositional element. The picture has all of the properties that we would expect in a beautifully made photograph, one created by a person who is a technical genius. The portrait of Adamson is vastly different. Is it possible that we can begin to discern the different artistic personalities of the two men by accepting what I would like to propose as the circumstantial evidence that each made the picture of the other?

SS: No, I don't think so. Hill was a painter, and one of the reasons he was so passionately interested in photography was that getting models for figure studies was particularly difficult. One thing that is obvious in the whole group of Hill and Adamson portraits is that Hill is photographed more than anybody else. You can't put this down to vanity; what he's doing is using himself as a model to try out var-

ious poses, lighting effects, and so forth. He is also very experienced in the construction of tableaux that he both devises and appears in, so I think he knows what he looks like in this image. He knows what position he's in, and he thought about the background; I think that's Hill's decision. I believe he also posed Adamson, but that hasn't worked so well.

WN: So you're saying that these two photographs are both, in composition and posing, essentially the work of Hill, and that Adamson is occupying the position of camera operator and not of creative participant at this particular moment?

AL: It would seem that Adamson was more comfortable behind the camera, as there is a discomfort in the portraits in which he appears. Hill is a self-assured artist who experiments with different styles, whereas Adamson just looks so uneasy, not even looking at the camera. I think this reveals more the age difference. Hill has experience behind him; this is most likely a learning process for Adamson.

WN: In these two photographs the men are posed in very different positions. Adamson is leaning on a table in a manner that is very typical of the first stereotyped way of making a photograph. By contrast, Hill is shown boldly in an environmental context that does what most portraiture is supposed to do, which is tell you something about the person by the context in which they're presented. Analyzing these two pictures in terms of their differing relationships to historical precedent reveals a real gulf between them. If these are by the same person, what we're talking about is a very schizophrenic artist, somebody who can be original to the point of genius and at the same time be conventional to the point of boredom. If it's Hill, how could he have been two things at once?

SS: He was more than two things at once. One of the words that was used about him at the time was *versatile*. If you look at the whole body of Hill and Adamson's portraiture, you find that there is a remarkable change from one picture to the next.

Jonathan Reff: I'd like to comment on the authorship of the photograph of Hill. Given the apparatus that Hill and Adamson were using, it would have been easy for two people to look at the ground glass. Both could be under the dark cloth or looking at it alternately. However, it's very difficult technically to make a self-portrait that way. Hill could have had someone stand in for him while he was look-

ing at the ground glass, but as soon as he entered the picture again, it became a completely different image. I have to think that Adamson had more of a role in making this. Hill was obviously very aware of himself and how he was posing, but only Adamson saw the image before it was made.

AL: It's interesting to note that Hill, in a letter to David Roberts in 1845, commented that his role was that of the artist, not of the technician. We have to assume that Adamson is the one who is actually executing the photograph.

AM: Which makes it one of those collaborations where you can't actually find an answer to the question of who did what.

WN: I'd like to move on to the group portrait of the Adamsons (p. 102). We have present in it two of the early geniuses of photography in Scotland—John and Robert Adamson. Is it likely that Hill had anything whatsoever to do with the creation of this picture?

AM: This photograph was probably made in St. Andrews. It shows three men and three women, possibly Adamson brothers and sisters, survivors of a family of ten children. John is on the left; Robert, on the right. Because there were people in St. Andrews who knew the calotype process, Hill and Adamson would have been able to borrow chemicals even if they hadn't brought any themselves.

WN: So if we agree that it was made in St. Andrews, which is a day's journey from Edinburgh, where Hill's principal residence was, do you think it's plausible that Hill would have accompanied Adamson on what was essentially a family reunion and been present at the time that this picture was made?

SS: Yes.

WN: Well, I think not. It seems to me that this picture does not look very much like most of the others with which we can plausibly associate Hill. It has none of the stereotypical hallmarks that a painter would know about the traditional composition of a group. As a trained painter, Hill would have given it structure, and this is a classic snapshot. Therefore, some of the circumstantial elements can be analyzed for how they reflect upon what may be called the Adamson style, whether it's John

or Robert. I would like to propose that one of those traits is the absolute avoidance, through ignorance, of the classical elements that would have been learned in an art academy, such as how to arrange a group.

JR: That's Robert on the far right?

WN: Yes. He's in the position of having just come into the picture after composing it.

JR: And of course he can't see on the ground glass that he's going to be cut off.

WN: Exactly! That is a very important deduction. It leads me to propose that Robert is the author of this picture and that what we see here is a very important stylistic hallmark of his—an avoidance of the classical elements of composing a picture and recognition of the more instinctive and purely photographic aspects. For that reason, I believe the portrait of Hill at Rock House could easily have been made by the same person who is using an unlearned approach to photography in this image.

SS: I would take issue with your phrase about painting and stereotypes. I believe the idea that Hill was fixed on a stereotype because he was trained as a painter is seriously incorrect. I think he recognized that photography opened up a field of possibilities, that it could be experimental. Like drawing, you could try out ideas and look at things in different ways. To decide that something original couldn't have been done by Hill because he was a painter seems to me to be quite a dangerous argument.

AL: It should also be mentioned that Hill used this image of Robert Adamson as the basis for Adamson's portrait in the Disruption Picture (see p. 9), which suggests that Hill was involved with the making of the photograph.

DF: The question of authorship is also relevant in the photograph of the south entrance to St. Salvator's College Chapel at St. Andrews (p. 110), which has been attributed to John or Robert Adamson. It's one of 190 prints from what's known as the Brewster Album. Brewster's name has come up already, but we haven't fully identified him.

AM: Brewster was a major figure in European scientific and cultural circles and knew vast numbers of people with whom he kept in touch through voluminous

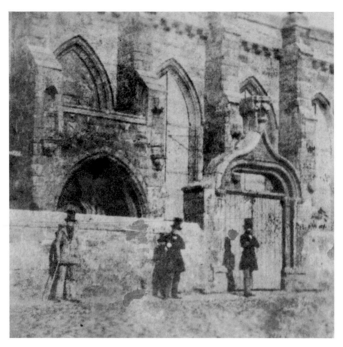

John or Robert Adamson.
The South Entrance to St. Salvator's College Chapel,
St. Andrews, circa 1842–43.
Salt print, 9.6 × 9.9 cm. 84.XZ.574.6.

correspondence. He made great contacts at Edinburgh University while he went through the four-year liberal arts curriculum, and he very much impressed the scientists of the day. He spent most of his life working as a scientific journalist, popularizing the field by producing articles for various publications.

In 1838 Brewster was appointed principal of the United Colleges of St. Salvator and St. Leonard at St. Andrews. When he arrived there, he had known Talbot for some ten years. It's apparent from surviving copies of their correspondence that they were working hard on developing photography from late 1839 onward.

WN: An important point to be made is that even though Talbot was gregarious, he had very few close friends that he confided in completely. I think it's fair to say that he considered Brewster one of those friends and confided in him in a way that was

exceptional for Talbot. It was partly because of this great trust that Brewster obtained enough information for the calotype process to be re-created in Scotland.

AM: I think the aspect that brought them together was their interest in optics and effects of light, of managing to capture an image. They were interested in spectroscopy, which was a very new science developing at the same time as photography.

JR: This photograph of the college chapel is curious to me in terms of composition. It seems a perfect example of an image made by someone who is interested in the subject matter but has no clue about putting a picture together. It is not clear whether the subject is the three people who are standing there, even though they are much too far away to be so, or whether it is the entrance, which is not presented in a way that draws attention.

WN: Within the body of work that is said to be by John or Robert Adamson, there are two very different approaches. One is, as Jonathan has just described, highly exploratory, while the other is more refined.

AL: There was a lot of experimentation going on at that point. They were trying out different things, such as portraits and town views, so there is a wide range and a disparate style. Some images appear to be sophisticated; others look very amateurish.

SS: In a scrapbook of early St. Andrews photographs in the Royal Museum of Scotland's collection, there is a list of places and times in John Adamson's handwriting, which suggests that he and Robert were testing different papers, chemicals, or lenses using particular sites and times of day as models. The other possibility is that John was using this list when he was teaching Robert, that he would say, "Go and do that view at this particular time of day and see what you can make of it; this seems to me to be the best light." There was only a short period between when John Adamson first succeeded in taking a portrait photograph and when Robert went out into the world as a photographer. During that time they must have been desperately anxious to make sure that the technical side of it was going to work. When Brewster stated in an August 1842 letter to Talbot that Robert was "well-drilled in the new art by his brother," I think this is what he meant.

DF: It's worth remembering that photography students even today go through a similar experience of both making the process work technically and making an

image work visually. The photographers in St. Andrews in the 1840s were doing the same thing, but they were doing it for the first time.

WN: Can we focus our attention for a moment on the portrait of Brewster (pl. 1)? This is a picture that has always been attributed to Hill and Adamson. It looks like much of their other work in that it was made with a camera of the same size, the print is toned, and it's faded at the edges. However, as Alison has told us, Brewster lived in St. Andrews, which was the home of the Adamson family and a day's journey from Edinburgh. Given the very close personal friendship between Brewster and the Adamsons, and by looking at circumstantial elements, such as the posing and averted eyes, can we say that this is conceivably the work of Robert Adamson alone? Or, when it came time to portray Brewster, did both Hill and Adamson go to St. Andrews? I think Hill stayed home when Adamson went to St. Andrews.

AL: But that assumes this was taken at St. Andrews.

WN: That's true. You could also say that Brewster came to Edinburgh and is seated in the studio. Do you recognize something that's in other photographs?

SS: I recognize the table; it's one that Hill and Adamson used in the Rock House studio. The photographs were actually taken outdoors, in the garden. I don't think there's anything problematic about Brewster being in Edinburgh. He was there in May 1843 when he introduced the two men, so he would have been among the first people that they photographed.

AM: The real clincher is that this is the photograph on which Hill based his portrait of Brewster in the Disruption Picture.

WN: Right. Brewster was a fervently religious man who was involved in the Free Church proceedings. Therefore, he would have been a central figure to the painting, and Hill would have wanted to be a participant in making this portrayal because of that.

AM: John Gibson Lockhart, the biographer of Sir Walter Scott, wrote about this picture in a letter of March 28, 1844, to Professor John Wilson: "Somebody showed me a lot of Edinburgh daguerreotypes. . . . That of Sir D. Brewster is by far the best specimen of the art I had ever seen."

WN: Is he talking about a daguerreotype or a calotype?

SS: He is talking about a calotype. I believe there was confusion between the two terms in these early times.

WN: So Brewster was probably photographed in the summer of 1843 when he was in Edinburgh for the Free Church meeting.

AM: Well, possibly the following year.

WN: So this is not 1843?

AM: It's certainly by March 28, 1844. That's the date of the letter about the Brewster portrait.

WN: No later than the spring of 1844, and possibly in the summer of 1843.

AM: Yes.

SS: Adamson was in St. Andrews without a camera during the winter of 1843–44. The picture was probably made in 1843 rather than 1844.

WN: I am trying to establish a date because, if we compare the picture to the John Adamson/Robert Adamson work that we've been looking at (p. 110), the most striking difference is the relative perfection of the Brewster portrait. It is richly toned, more or less uniform from edge to edge, and has an extraordinary range of light. It represents a significant technical advance in whatever period of time existed between the making of the two pictures.

In 1845 Hill wrote to David Roberts, as Sara has so ably and generously made known to all of us in her painstaking transcription of the letter: "I believe Dr. Adamson & his brother to be the fathers of many of those parts of the process which make it a valuable and practical art. I believe also from all I have seen that Robert Adamson is the most successful manipulator the art has yet seen, and his steady industry and knowledge of chemistry, is such that both from him and his brother much new improvements may yet be expected."

The main point is that Hill thought Adamson had made improvements to the process that were fundamental. I think it's important for us to establish that by late 1843 or early 1844 it was possible to make a photograph in Edinburgh that

was more perfect than any photograph on paper anywhere else in the world. In France, Hippolyte Bayard's pictures were still pale and insignificant. In London, Talbot's *Pencil of Nature,* created between 1844 and 1846, is a published work that shows what calotypes could look like at the time. Nothing approaches the perfection of the best Hill and Adamson calotypes.

There is no doubt in my mind that what Hill wrote to Roberts represents an absolute truth of which we are ignorant of the details—that Adamson invented, or added, something to the process of photography that made it possible for their pictures to look more like what we expect pictures to look like today. What was added? What is the element that made the pictures look so great?

SS: Something else that could be acknowledged here is that, given such a phenomenally large output, their success rate was remarkably high. In another passage from the same letter, Hill says, "I can only say that Adamson says the manipulation is very liable to go wrong in the hands of most people—that tho' several have now and then produced a good specimen—they find it difficult to succeed often."

The question Weston raises is extraordinarily interesting. There are possibilities. One is that there was something in the water in Edinburgh. I think there might have been a high proportion of iron in the water, which might explain the density of the black and brown. This is the color that they were looking for.

WN: So you're suggesting these pictures have the color they have because there is an inadvertent iron toning added from the water.

SS: It isn't necessarily inadvertent. They may even have known it was there. I think to assume that anything happened as a result of accident is rash. These two knew what they were doing.

JR: There is always the element of an accidental discovery that is then recognized and capitalized on.

SS: Oh, yes, an accident has to be seen for what it is and then seized.

WN: Your suggestion that the water could have made a difference is an important thought, because we know that water is fundamental to making a photograph. However, my feeling is that there is so much consistency in the appearance of the

pictures that it has to be something far more under their control than water.

DF: The next photograph, *The 92nd Gordon Highlanders,* gives us a chance to look at an actual calotype negative (pl. 8) and compare its properties with those of a print made from it (pl. 9).

WN: One of the interesting properties of the paper negative is that you can see the reversed image on the surface of the paper, unlike the later glass negative, which can only be properly seen by holding it up to light. The paper negative itself has a visible decorative quality.

SS: When Talbot first demonstrated the negative process, quite a few people were taken aback. They were expecting to see a photograph made directly, a straightforward and positive impression of reality in the same way a daguerreotype was. Quite a bit of energy was expended in the 1840s toward making a positive print directly on paper.

What's intriguing about the calotype process, and is particularly noticeable in this photograph of the soldiers, is that because the chemicals actually sink into the fibers of the paper, the picture disappears slightly into the face of the print. The fibers give the image a subtle sense of movement.

JR: Looking at the negative from a technical point of view, you can see how well exposed it is. There is detail into the darkest areas of the shadow. That's a considerable feat, especially since Hill and Adamson didn't have our modern ways of measuring light and the materials were rather insensitive. Do we have some sense of how long their exposures were?

SS: It could have been anything up to three minutes, but I think in most of their portraiture they got it down to seconds. That's another impressive technical feat.

AL: Particularly when you have a group such as this. With more people to maneuver into place, it starts to get more difficult, as everyone was required to remain still.

SS: Something to realize about this picture is that Hill and Adamson went to Edinburgh Castle and arranged to use the soldiers—who were used to standing still—as models. It's an example of the kind of influence that they could exert. They didn't

just turn up, they organized it in advance. Group sessions like this obviously took at least a day or more to complete.

WN: In an article by Hugh Miller on the calotype published in *The Witness* on July 12, 1843, he talks about one of the great virtues of the process being its speed. He says, "The photograph was the work of but a few seconds." I think they generally must have been able to make exposures in less time than we expect.

SS: I think so, because they succeeded in taking successful photographs of children, and not only children pretending to be asleep.

WN: While we're looking at this negative, I think it's important to mention that Hill and Adamson, particularly Hill, recognized that one of the most important aspects of the negative-positive form of photography was that it made possible multiple prints that could be used for some form of book illustration. Referring once again to the Miller article, he compares the calotype and the engraver's art and says the calotype will make possible, "in all probability, a new mode of design for the purposes of the engraver, especially for all the illustrations of books." As we've heard today, before Hill was a photographer, he was a book illustrator. He thought of the calotype as a way of creating new kinds of illustrations for books. His first choice of presentation was to put these calotypes into albums. They were usually not seen displayed on museum walls as they are today.

DF: The next photograph we'll look at is of Durham Cathedral (pl. 21). Hill and Adamson made it on an expedition to York, England, for the meeting of the British Association for the Advancement of Science in the fall of 1844.

WN: I'd like to refer back to the letter that Brewster sent to Talbot in July 1843, where he discusses the formation of the partnership and the various kinds of work that it was planning to do. He wrote: "Mr. D. O. Hill, the Painter, is on the eve of entering into partnership with Mr. Adamson and proposes to apply the Calotype to many other general purposes of a very popular kind, & especially to the execution of large pictures representing difft. bodies & classes of individuals." The phrase *large pictures* is pertinent here, because this print is from one of the largest calotype negatives that Hill and Adamson ever made. Do we know anything about the impetus for using a camera of this scale?

SS: I think the use of the large camera was quite straightforward. Hill's brother Alexander was a print seller. He had an art gallery and was producing large-scale engravings of the works of Scottish painters at the time, including some of Hill's oils. Hill was trying to increase the size of the calotypes from the comparatively small 8½-by-6½-inch format of most of the portraits to something that was more impressive as a physical object. He lent a group of these to the Photographic Society of Scotland in 1856 and said that he didn't think anything near this size was being produced by anyone else in the 1840s.

WN: In my opinion, this picture has much in common with the views that photographers made of monuments to sell to tourists as souvenirs. This brings us to the commercial impetus for the Hill and Adamson partnership. On the one hand, they must have expected to earn revenues from doing commissioned portraits, of both individuals and groups, but on the other hand, they would seem to be trying to earn revenues by creating pictures that they could produce for sale to tourists, such as this view.

By 1844, when this was made, they were really searching for revenue in order to make the partnership viable. Hill had already spent a lot of money out of his own pocket, so the question raised by this picture is whether it would satisfy a tourist need. Would anybody buy this as an illustration of a romantic or a historical place? Or was the ambition to sell such pictures totally unfounded?

AL: It's such a large print and difficult process that this doesn't seem like an enterprising thing to do if you're looking to sell large numbers. I like to think of this as being more of Hill and Adamson's personal record of having gone to York. Hill was a landscape painter and was used to working in different sizes and media, and this is so classically arranged that to me it is more of an attempt to use photography to do something that he perhaps would have done before in watercolors or pen and ink.

SS: I think Hill and Adamson did have the idea of selling the pictures, but how far they can be regarded as commercial I am not clear. When you think of this as a commercial exercise, you have to bear in mind that Hill isn't going to compromise in the interests of making it work. He is concerned with doing the best he possibly can with the process. As he wrote in a letter to David Roberts on March 14, 1845:

"Much money could be made of it as a means of cheap likeness making—but this my soul loathes."

AM: The same was true for Adamson. Brewster wrote to Talbot on May 9, 1843, the day before Robert went to Edinburgh, "His Risk & outlay are considerable; & he is therefore anxious to make a good beginning." So, Robert too had sunk considerable money into this way of making a living.

WN: As a practical question, how did Hill and Adamson pay their bills at the time?

JR: We talked about Hill beginning to receive a salary as secretary for the Royal Scottish Academy in 1836, so he'd been doing that for a number of years. Can we assume that he was supporting himself by the book illustrations?

SS: Yes, but there's no doubt about the fact that there wasn't any money; the whole enterprise would have gone bust in a couple of years if Adamson had lived. There is a letter from Hill, written a few months after Adamson died, in which he says he hasn't managed to sort out the legal part of the partnership with "Mr. Adamson's relations who with myself have been put to heavy expenses by these our Calotype interests." It's very sad, but I don't know of a single one of the big albums that was actually sold. As far as I am aware, they were all given away. The calotypes were selling as individual prints, but not as albums.

JR: Were the photographs being sold by Hill and Adamson directly?

SS: Either by Hill and Adamson or by Alexander Hill.

Another problem regarding the commercial aspects of the Durham Cathedral photograph is that Hill and Adamson were allowed to make pictures in York only after asking Talbot's permission. I don't know whether or not they ever persuaded him to give them permission to sell the photographs in England. It was rather a tricky situation.

AL: Talbot, of course, traveled to Edinburgh right after the British Association meeting to make photographs for his *Sun Pictures in Scotland*. It's interesting to compare his image of the Scott Monument (p. 119) with the earlier view by Hill and Adamson (pl. 20).

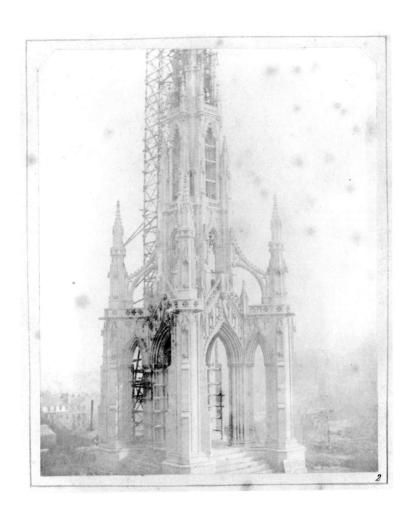

William Henry Fox Talbot.
Scott Monument, October 1844. Salt print, 19.3 × 15.6 cm.
84.XZ.573.2.

AM: Having acknowledged the financial difficulties, I think it should be noted that this picture of Durham Cathedral was well received by Hill's peer group. Elizabeth Rigby wrote in her journal on December 19, 1844, "To Mr. Hill's to see his wonderful calotypes—one of Durham most exquisite." His friends were very supportive in what they said about experiments of this nature.

WN: I'm fascinated by what we're exploring here with Sara's and Alison's responses, because clearly Hill and Adamson were of two minds about what they were doing. It was a pure artistic endeavor into which they'd sunk a lot of money; it had the potential to be profitable but never was.

DF: As with the Durham Cathedral image, there is speculation about the reason the photograph of John Knox's house (pl. 14) was made.

WN: Some of that speculation starts with the physical properties of the picture. Surrounding the image is the black border that would have been at the edge of the negative. The print, with all its irregularities, is essentially as it would have been before Hill and Adamson prepared it for final presentation. I don't know whether this example was made much later by someone who wasn't so concerned about its appearance or whether it's a rare, surviving, untrimmed proof before mounting. We may never know.

AL: This comes from an album that appears to have been in the collection of the Hill family. In the frontispiece there is an invitation to an event celebrating Hill's second marriage. His obituary is also pasted in there.

WN: What is the significance of the image?

AM: It's the High Street, the main street of old Edinburgh. We're looking at what was purported to be the house of the great patriot of the Scottish Reformation, John Knox.

WN: Was Knox related to the Disruption Picture?

SS: The connection was overt. The idea for the Disruption Picture, I think, came into Hill's mind because of two paintings by David Wilkie that featured Knox as the central figure, one of which actually belonged to Alexander Hill, who bought it

after Wilkie's death. Lord Cockburn, responding to Hill's proposal for the Disruption Picture, said there had not been such a subject since the days of Knox, and perhaps not then. The Free Church saw itself as leading the same kind of fight that Knox did. He was their hero.

AM: Religion permeated nineteenth-century life in a way that we in the twentieth century have put to one side. It certainly pervaded the Scottish character at that time.

The Old Town of Edinburgh was very cramped; it was a slum, full of disease. Cholera raged in these closes and landings several times during the 1840s. The Victorian response to squalor was to tear everything down and start again, but running against this was the feeling that some of the architecture was important historically, particularly Knox's house.

SS: The house was also causing an obstruction in the road, so it would have been a real temptation for town reformers to tear it down.

AM: It's still there today. Lord Cockburn was very keen that the best of historical Edinburgh architecture should be maintained. He fought a fairly prolonged battle to preserve this house and indeed was successful.

WN: Does it strike you as peculiar that, given the fact that John Knox's house is the ostensible subject, the camera is positioned so far back on the street that it doesn't give the house prominence?

JR: It would be a stretch for me to accept that Knox's house was the subject. The building in front of it is positioned quite prominently; it's the only building that's fully described. I think there must have been a desire to capture the whole street, since it was the main street, and not just document the one building.

AL: If you look on the left side, there's a ghostlike figure with a tripod and what may be a piece of dark cloth on the ground. Perhaps Hill and Adamson were experimenting with different viewpoints and this is just one example. Maybe a view from the other tripod would have provided a more prominent position to the house. There are variants of this image, but they are from the same distant perspective as this one.

SS: Another incidental detail in this work is the collection of busts in the first floor windows of the building at left. There was obviously a seller of statuary in that

premises. I suspect that one of the reasons for coming back so far in the composition was to include that little line of portraits looking at Knox's house. It's very engaging; it adds life to the picture.

WN: Anne mentioned that this photograph was in the Hill family album; in that volume there are very few outdoor views. Whoever created the album included this picture because it was especially meaningful for some reason.

SS: Amelia Paton, whom Hill married in 1862, was a sculptor. It could be that this caught her eye because of the little group of statuary.

WN: It may not just have caught her eye; she may have had a connection to those sculptures that was more than passing, although we don't know what the connection might have been.

SS: As far as I know, she wasn't prominent in Hill's life in the 1840s, when this picture was made.

DF: Of course, Hill and Adamson may have taken this photograph for one reason, and it was later placed in the family album for an entirely different reason.

WN: And we are looking at it today with great interest for yet another reason. I happen to like this picture a lot, partly because it reminds me of the work of André Kertész and others, where the ambiance of the activity of a street is recorded.

JR: It makes me think of Atget's photographs.

DF: Let's continue by comparing two group portraits. One depicts representatives to the Free Church Assembly in Glasgow in October 1843 (pl. 3); the other shows ministers from the Dumbarton Presbytery and is dated March 29, 1845 (pl. 29).

WN: The Glasgow picture was given to Brewster by John Adamson and appears in the Brewster Album. The print holds interest for us because it is so much in the style that we have already associated with Hill and Adamson, yet Brewster identifies it with the inscription "R. Adamson, Phot." This once again prompts the question of who made the picture, Adamson alone or Hill and Adamson?

The figures are seated in front of a textile backdrop at a table draped with a cloth. A couple of books in the foreground are propped against a large bowl,

forming a still-life arrangement intended to provide a visual context for the men's legs at the left and right sides of the composition. The scene is illuminated by a strong light striking not from overhead, but from an angle directly behind the camera. It appears that Robert Adamson learned from his brother this basic formula of posing figures around a table illuminated by sunlight from behind the camera. The still-life arrangement that fills the foreground is typical of a painter's conceit, however, and could well have been Hill's idea.

The Dumbarton Presbytery picture has different characteristics. It has a much bolder tablecloth, for example. It has some design elements that would seem to be more thoughtfully composed, and therefore looks more like the work of somebody like Hill.

SS: But if the Glasgow group was intended as a study for the Disruption Picture, then it had to have involved Hill. My feeling about the image is that it was a photographic sketch, that Hill and Adamson weren't worried about such compositional elements as the backdrop.

AL: Perhaps the fact that it was made in Glasgow, away from the studio, also contributed to its eccentric look.

It is interesting to observe how Hill and Adamson made the Dumbarton image more dynamic. They've come in closer on the participants; we're suddenly right in the middle of the discussion. There's a very intimate feel to it, and the composition is far superior. Obviously it has something to do with their having more experience in what they're looking for by 1845.

SS: I don't think it's so much that it's a later date as that Hill had different ideas in mind here. In the Glasgow image he is straightforwardly making a sketch for the Disruption Picture, and in the other there is the secondary idea that the photograph could stand by itself.

DF: If the Glasgow portrait were done as a sketch, then why go to the trouble of arranging the books in the foreground and the rope in the background? Michael, you've just joined us—do you have any ideas on this?

Michael Wilson: If you were making a sketch and were just interested in the heads, this certainly doesn't seem like the composition you'd end up with. This looks like

it was made by someone who was trying to compose a piece and was worried about getting the full-length figures in. If the picture had no attribution, I would not immediately say it was by Hill and Adamson. Conversely, I have no trouble crediting them with the Dumbarton picture. The conversational interaction among the characters in that image is very strong.

JR: The Glasgow image, I think we're all agreeing, does not have the force of the Dumbarton picture. It seems much more staid and awkward, like something one would paint. It may be that when they began, Hill and Adamson were working from the idea of painting. The discovery that that approach didn't really work led to the creation of much more dynamic photographs later on.

DF: The Dumbarton photograph has a much greater sense of immediacy. Even though we know it was set up and took a relatively long time to expose, there's an intense, slice-of-life snapshot quality to it.

WN: You can't underscore enough how unusual that element is in the photographs not just of this time but even of twenty years later. It was extremely difficult to get that dynamic, animated quality that Hill and Adamson have achieved in the Dumbarton picture. Let's assume, then, that what we're talking about here is a stylistic evolution. They simply knew how to make photographs better by 1845 than they did in 1843.

JR: And they're becoming less painterly and more photographic.

WN: That's absolutely true. The Dumbarton image has some notable elements that are purely photographic. Take, for example, the chair with the curved arm. A painter would almost certainly have completed the curve at the bottom, whereas in this case the picture has been framed so that the composition ends right in the middle of that curve. Ending a compositional element somewhat arbitrarily is usually described as a photographic motif.

JR: And the hand appearing on the shoulder at the left is surprising. From a painterly point of view, it would have been a mistake.

WN: But somehow it doesn't look wrong in the photograph.

JR: It gives it a sense of immediacy, I think.

SS: I feel very strongly that the challenge of depicting groups of figures was one of the driving forces behind the photographs Hill and Adamson made, because the basic challenge genre painters faced was observing groups of people. David Wilkie expressed this years before photography arrived when he talked about capturing the instant, the moment. There are two obvious problems Hill faced with the Disruption Picture. One was to get the portraits of individuals; the other was to get some sense of people relating to each other in groups. It was particularly difficult to convey an idea of how people relate to each other physically within space. For Hill, the privilege of being able to organize subjects in a tableau that could then be photographed and looked at later must have been very exciting indeed.

I think Hill is especially good at the type of composition we see in the Dumbarton image, which is a kind of human architecture, if you like. He can persuade people to form a group and make them look natural.

WN: It's worth noting that the Dumbarton calotype is one that was transposed almost exactly into the great painting. Hill obviously had a very high opinion of the success that was achieved here.

SS: Ironically, rather than helping the Disruption Picture, I think photography eventually wrecked it. By the time Hill and Adamson finished making images, Hill had something like four hundred portraits to work into the painting. Each person had to be recognizable, and that's a definition of impossibility. What he was trying to create was a democratic painting of a great event; he was giving each person in the picture relatively equal weight. I can't think of an equivalent in any other circumstance. Also, by the time he finished the painting, everybody had aged and some people had died. In the picture he's aged a number of individuals, including himself, but Adamson, who is shown with his camera, is, of course, the same age as he was in the 1840s (see p. 9). The effect is very strange—Hill has compressed twenty years of history into one apparent moment with the aid of photography.

WN: There's no doubt that after the advent of photography time came to be understood in a different way, because you had a method of measuring changes in a factual manner that never existed before. Hill may have been one of the very first people

to recognize that the photograph stopped time. Maybe in his painting he wanted time to begin flowing once again.

DF: Let's move on to the Newhaven pictures. Most of the photographs we've been discussing, like the two group portraits, were done in an outdoor studio situation, such as the garden at Rock House. They are designed to appear as though they were done indoors, even though we know they weren't. For the Newhaven pictures, however, Hill and Adamson took their camera out into the town and documented the people who were there. How did these photographs come about?

SS: At the time, Newhaven was a very small town of about two thousand people; three hundred of them were fishermen. It was on the shores of the Firth of Forth, about a mile from the center of Edinburgh.

AL: Newhaven was a fishing village that attracted a lot of attention at the time. It was held up as being a good example of a community that supported itself and had fine, moral, upstanding values. This is very much a case of two essentially middle-class men embarking on a photographic adventure and looking at a working-class village. Although there is an obvious picturesque quality to these images, partly due to the clothing, we never see the people in their Sunday best; they're always in their work clothes. The villagers are identified purely in relation to their jobs and social station.

As Weston read earlier, Hill had announced that the partnership was going to look at different classes and kinds of people, but it is interesting that they would turn to a fishing village at a time when there was a lot of industrial change going on in Scotland.

AM: And the possibility of revolution.

WN: The word *revolution* wouldn't normally come to mind in connection with the Scottish temperament of this time. One imagines Scotland as a society of great stability, of relative prosperity for all, of scientific progress. Yet when we looked at the John Knox picture, you said that that part of town was uninhabitable because of pestilence and filth in the area.

SS: It wasn't just the problem of disease. The Old Town had become crowded not

only because the richer people had moved to the New Town but also because a series of industrial slumps and the Highland clearances had forced poorer people into the cities in search of work. What happened in the center of Edinburgh applied to the center of all the major cities in Britain. When people are in a dire state of poverty and ill health, they have a very high mortality rate, and that high mortality rate affected every part of society.

AM: The effects of the industrial revolution were particularly marked in the west, certainly in Glasgow, which was a much more industrialized city than Edinburgh. The great middle-class fear during those years was that the whole thing would boil over and erupt, as indeed it did on the Continent in 1848 with the February Revolution in France.

AL: Many people, such as Lord Cockburn, did see a potential threat from the lower classes. He wrote in his diary by 1848: "The man must be very blind who does not see the shadow of the popular tree is enlarging and darkening; and he must see well who can tell us what its fruit will be. . . . Will experience and education change human nature, and men become wise and good? Or shall we go on in this perpetual swelter? Or will manufacturers be given up, and the pastoral-poetry state be returned to?"

WN: Do we see any signs of revolution in the faces of the people in the Newhaven photographs?

SS: Well, no. There are two things you can do when there is this kind of distress. You can either photograph the distress and hold it up to the world and say, "This is really bad, we should do something about it," or you can hold up what's going right and say, "This is admirable, this is heroic, this is what we should be looking at," with the idea of seeing whether society and the economy can also be reorganized in this way.

I don't say that Hill and Adamson's photographs in Newhaven were an overtly polemical exercise of this kind, but I think that this idea underlies them. Hill could have taken photographs of sad people in distress, but he didn't want to do that. He was a man who had a preference for looking at the ideal, at the optimistic possibility.

The people in Newhaven ran their own affairs in a very solid and social way, but they were heroic too. I think it's particularly obvious in the portrait of James Linton (pl. 33). These are people who are greatly admired not only for their physical strength but also for their heroism. They had a reputation as impressive sailors, which they richly deserved.

MW: I think what's interesting about these pictures is that they are so varied in their subject matter and are so good.

SS: These photographs are an extraordinary exercise; I don't think there is a precedent for them. There are roughly 130 photographs taken in this series, and you can see from the group picture of the men gathered around the boat in their top hats (pl. 37) how many people were involved. Hill and Adamson did not just walk down to Newhaven with their camera saying, "Let's take some photographs today." Hill had already been there painting in the 1830s; he knew the people.

JR: Do we know over what period of time the series of pictures was made?

SS: It started in 1843; Brewster refers to Hill and Adamson's calotypes "of the Fishermen & women of Newhaven" in a letter to Talbot dated November 18, 1843.

AL: I think by 1845 the series was close to ending; Hill wrote to David Roberts on April 26, 1845, and said, "We are preparing Fishwives for a book, and have done some fine things lately."

MW: What I'm struck by in the print of James Linton is that it is very typical of the portraits for the Disruption Picture. The image of the group of fishermen has a different kind of arrangement. I'm fascinated by the way the compositional quality of the top hats and the light trousers is structural. It's the type of thing we've come to think of as a modern idea in composition. There's a slight sense of informality, but it is very architectural in the way it is composed.

SS: One of the things that pleases me about the group picture is the extravagant use of all these men in all these hats, all different shapes and sizes. Different levels of light bounce off of them in a way that couldn't be done in a formal group such as the Dumbarton Presbytery, where everyone had to be recognizable.

WN: The composition of this group of eleven men is remarkable because the exposure has been made with all but two or three of them looking somewhere other than at the camera. Did Hill and Adamson stage this appearance of informality? Are we seeing a grand illusion as in the Dumbarton picture?

SS: How could it not be staged?

WN: The man in the foreground, in profile, looks so much like he's about to start walking that to me it genuinely appears that the picture is trying to give the impression of a candid moment, if it's not actually such a moment.

SS: A response that Hill and other early photographers experienced was that when they made a picture that looked natural, everybody assumed it was. I think this is something that is convincingly constructed.

MW: Even though it looks like a candid group, very few people really mask anyone else, especially with their hats. When you look through the Newhaven pictures, all of the groups are posed, but in a deceptively natural way that even today would be admired.

SS: It's significant with most of these photographs, particularly the ones where the group is fairly small, that we know who the people are. Hill was careful to write down James Linton's name, for example. This is very important, because these are not just studies for a painting, but people being photographed in the same way that a formal portrait would be taken, whatever that person's status. I think Hill became much more involved with them as individuals from 1844 onward.

MW: I haven't had quite the same feeling. Linton's portrait is clearly about him, but the other seems like a tableau vivant. Instead of doing as Talbot did—which was to dress up his servants as fruit sellers or fishmongers and stick them in the garden—Hill and Adamson went out in the field and used authentic subjects.

JR: But even with the Linton photograph, if you compare it to the other portraits, his face is mostly obscured in shadow. You get a sense of a character, of maybe a role or a type, but I think less of a sense of an individual person.

WN: How would you analyze the portrait of Mrs. Elizabeth Hall (pl. 34)?

MW: As with the Linton picture, I feel that this is a portrait of a person rather than a genre study. It also has that highly graphic structure we've been talking about.

WN: I've always loved this picture. The basket is such a wonderful metaphor of the female as an extraordinary vessel capable of infinite patience, love, courage, and work. It touches an emotional chord in me as a symbol of human existence.

DF: *Fishergate* (pl. 41) is a very different kind of image, with a large number of people depicted in a highly organized way. Is it also from Newhaven?

SS: No, it's not. The book that Hill and Adamson were planning to make with the Newhaven photographs was called *The Fishermen and Women of the Firth of Forth.* I think it was called that, instead of *Newhaven,* because there were certain characteristics that Newhaven did not have that would be needed for an understanding of fishing life in the broader sense. This photograph of the market, for instance, was taken in St. Andrews.

This is an extraordinary picture. Look at the practical organization of this, how dependent the whole thing is on the shadow of the woman apparently walking across the street and how precisely everybody is placed in relation to the light and dark areas of the building. I get immense pleasure from the thought of Hill running up and down a flight of stairs, for who knows how long, adjusting people, moving them around, and waiting for the sun to come out so the shadow would be in the right position. To me, this picture probably makes the connection with filmmaking more than any other in the Hill and Adamson oeuvre.

MW: Everything you said strikes a chord with me. If this were a film set, this shot would take hours to set up and several assistant directors to get everybody in place. It's incredible in that sense.

WN: We've talked about Hill and Adamson as partners, and we've agreed that for the most part they were out there together—one more or less operating the camera, the other posing the subjects. Can we try to imagine what their ritual would have been like here? Is Adamson just standing by the camera while Hill is trying to dress the set and get the people organized? Or does the camera stand there alone with both Hill and Adamson out working with the people?

SS: I visualize Adamson standing up there behind the camera saying, "Oh, for heaven's sake, hurry up, D. O., the paper is getting dry!"

WN: So he's the pragmatist. Or would he be worried about the light?

SS: No, Hill is the light man. There's no question about it.

JR: I see Hill behind the camera as well, not operating it, but I don't think you can have a composition as perfect as this one without spending a lot of time looking at the ground glass. Hill divorces himself from the chemistry of photography, but I think he's very much involved in the optics of it.

MW: I suppose no one knows how that work was divided up, and it could be that Adamson was relegated to simply being the one who did the chemistry. But it's also true that when Adamson died, Hill gave up; he could have replaced Adamson if it were just a matter of chemistry. It's impossible to say, but I think maybe Adamson contributed much more.

JR: My point is not to diminish Adamson's role, but that I think it would be hard to imagine Hill not being at the camera and directing the framing and looking through it and then moving people accordingly.

MW: This is a big job. I wonder if they didn't have one or more assistants.

SS: There was an assistant, a Miss Mann, who came from Perth. James Nasmyth refers to her, and Adamson, in a March 1847 letter to Hill: "How goes on the divine solar art? and how does that worthy artist Mr. Adamson the authentic contriver & manipulator in the art of light and darkness? and thrice worthy Miss Mann that most skillful and zealous of assistants."

WN: Would she have been an assistant like those who helped the California photographer Carleton Watkins? They were chiefly responsible for making the prints. Given the number of Hill and Adamson images that survive, it's not unexpected that an assistant would work with the negatives—printing, filing, and organizing them.

SS: I think that's quite possible. I have no reason to think she was making the photographs, although Hill and Adamson were both periodically off sick.

WN: To me, this picture is a classic intuitive photograph, one made without any preconception of how a picture should be made. The photograph is successful because it accrues so many details that are irrelevant, that have nothing to do with massing or shaping or all of those things that we know Hill was so involved with.

That brings up an interesting question of how Hill and Adamson elicited the cooperation of the subjects both here and in Newhaven. Clearly the portraits for the Disruption Picture were arranged and their subjects wanted to participate, but what was the motivation for these people to cooperate?

MW: Do you think they were paid?

SS: I think it's quite possible.

MW: Do you think the woman in the street was a professional model?

SS: I'm quite sure she wasn't. This is the critical difference between what Hill was doing and what Henry Peach Robinson did later. There's a ludicrous passage in which Robinson says that you can't photograph real people out in the field because when you point a camera at them they become self-conscious and wooden. What you have to do is buy their clothes from them and dress up some pretty girl you happen to know, and then you get a wonderful picture. I think Hill was so concerned about the truth that he wanted the real thing, the real people.

DF: The stylized structure of this photograph, with its documentary character, is also seen in the allegorical pictures Hill and Adamson did, which are purely fictional.

WN: The image we're looking at (pl. 42) depicts Mrs. Elizabeth Cleghorn and John Henning in the roles of Miss Wardour and Edie Ochiltree from Sir Walter Scott's *The Antiquary*. This relates to a specific passage from the book and was clearly staged to be photographed.

MW: I've always been curious about the purpose of this image. Was it an exercise, a book illustration, or a work to be sold?

SS: Scott was world famous at that point; his novels had an influence on culture that is very hard to believe now. Hill belonged to a circle of people who had a ten-

dency to dress up, both for fancy dress parties and for tableaux. I think this photograph is from one of these types of occasions.

WN: I think it looks miraculously natural. It anticipates Julia Margaret Cameron's illustrations of Tennyson's *Idylls of the King* thirty years later. However, her treatment of the subject was sometimes unintentionally comical. Her photographs just don't have the naturalism that this one has. Hill and Adamson remarkably achieved the natural by artifice—in the portraits for the Disruption Picture, in the photographs of common people, and also in illustrations of literary passages.

SS: One of the recurring themes that we've been discussing today is the extraordinary variety of Hill and Adamson's work, the disconcerting way in which they tried so many different things. In those four and a half years near the beginning of photography they encountered a lot of the questions—and discovered many of the solutions—that later photographers would have to confront. In the 1890s James Craig Annan looked at their work and couldn't imagine how they had done it. I think the wide range of their photography and their sense of experimentation make them really remarkable.

DF: Your mention of James Craig Annan is a good segue to the final image we are going to look at today, a photogravure of Lady Ruthven (pl. 47).

WN: By considering this print, which was made by Annan in the 1890s, we can recapitulate a little of the later history of the Hill and Adamson partnership. They were recognized very early as having achieved something notable and were continuously admired by successive generations of photographers through the efforts of individuals who wanted to preserve the work and make it better known. One of these nurturers was Annan, who was actually the custodian of the body of work, is that correct?

SS: He probably had much of it in his hands, but I'm not absolutely sure whether he owned it. The physical connection with the Annan family came when Hill moved out of the Rock House studio in 1869, leaving the existing stock behind. Thomas Annan, James's father, took over for a year and then, for some reason that isn't explained, moved to Glasgow. Whether he took a lot of the negatives with him at that point I'm not sure.

Thomas Annan knew Hill very well; as a boy, James would have met Hill. Thomas was the one who made the big carbon photograph of the Disruption Picture when it was finally completed (see foldout). He greatly admired Hill and passed on his admiration to his son. Thomas had the rights to the carbon process in Scotland and printed the Hill and Adamson photographs in carbon; James went to Vienna to learn the photogravure process and, in turn, printed their pictures as photogravures.

WN: And it was through the photogravure connection that James came to know Alfred Stieglitz, who in the 1890s was making photogravures as a commercial enterprise in New York City. Annan introduced Stieglitz to Hill and Adamson's pictures, which Stieglitz then reintroduced in *Camera Work.*

This photogravure is a particularly provocative picture, because it is a portrait of a woman seen from behind. It is not a completely atypical viewpoint, but it's certainly an adventurous one unlike anything that we've seen so far today.

AL: This is more of an aesthetic exploration than anything else; nothing has been revealed about the subject other than her taste in fashion. Showing a woman from behind was very common in the fashion lithographs of the time.

WN: Photography would have been particularly adaptable to this lace shawl, which an artist couldn't really draw successfully. Through the photographic medium you see the remarkable gauzelike quality of the textile, which I'm sure is the effect that Hill and Adamson wanted to achieve.

DF: Has anyone seen this as a calotype? Is the transparency heightened in that?

SS: There's a bit more detail in the photogravure. Annan has carefully printed this on very beautiful japan paper, which gives it a particular transparency. It's not the same thing exactly, but a lovely translation of it.

I don't know as much about Lady Ruthven as I would like. She was an artist herself and very hospitable—she entertained Hill in her own castle. She was also known as a humorist, and I think there might be an element of that here. There is no front view of her; it may have been particularly frustrating for Hill not to be able to make her portrait.

MW: I've always seen a sense of tremendous stability in this picture. She seems so well grounded, and there's a quietness about it, a certain dignity. Not knowing her background, I never saw this as a comical thing.

SS: I don't think it was comical as such, but here is a middle-aged woman who is well known as a humorist as well as an artist. It's possible that she said, "Nonsense, my dear man, you don't want to photograph me from in front, but my word, I look elegant from behind."

WN: A kind of cheeky modesty. But it's so dignified. She's not tilting her hip or signaling anything provocative.

SS: Oh, no, she's a lady. She's a generous, hospitable woman who obviously likes the photographers or wouldn't be doing this.

I think this photograph may be one of the last that Hill and Adamson made. Hill wrote to Lady Ruthven in December 1847 and enclosed photographs he said were from their last session at Rock House. If this is indeed among the final photographs that were taken, there is something really very sad about the idea of somebody turning away.

AM: It's valedictory, isn't it?

SS: It's poignant, accidentally poignant.

WN: If I could continue with my theme about authorship here, I see this one, and many other of the standing female portraits, as being the work of Hill, with his compositional signature and ability to transform the figure into a study for a painting. Once again, this is unprovable, but if you were to array all of the works of this kind, there is yet another personality materializing, one that is deeply reverent of the opposite sex, who is taking great pleasure in analyzing the structure of the female form through his camera. I don't know why I think this; maybe it's the circumstances of his life.

DF: It's interesting that in Annan's text for the *Camera Work* issue he barely mentions Adamson. Did the reputation for these photographs we've been looking at today really follow Hill more than Adamson up to that point?

WN: I think there was some confusion as to the authorship. Stieglitz and Annan were focusing more on Hill's contribution because they were painter oriented.

AL: They were looking back, and they could see the bigger picture, if you like. Considerably younger than Hill, Adamson wasn't a communicator; he didn't convey in letters what processes he was using, what he was feeling. He didn't appear to be comfortable in front of a camera. He is very much an enigmatic figure in the background. Conversely, Hill was an established painter and very much the sociable gentleman. When Adamson died, Hill's life continued. It's understandable that Adamson's recognition would recede.

It was only in the 1970s that revisionist writings began to look at what Adamson's role might have been. And the fact is that we really don't know. That's why it's so interesting that we're here today, because there are so many questions.

DF: Is there anything later in Hill's life, after Adamson died, that indicates his assessment of Adamson's contribution to the work?

SS: What Hill said the day he helped to bury Robert Adamson is very touching. He wrote on January 18, 1848, to the painter Joseph Noel Paton: "I have today assisted in consigning to the cold earth all that was earthly of my amiable, true and affectionate Robert Adamson. He died in the full hope of a blessed resurrection. His true-hearted family are mourning sadly, especially his brother the doctor who has watched him as a child during his long illness. I have seldom seen such a deep and manly sorrow. Poor Adamson has not left his like in his art of which he was so modest."

WN: "Has not left his like," no one will exceed him, there's no one like him. That wonderful statement certainly dispels any notion that Hill felt remorse about entering into the partnership, although he and Adamson had spent a lot of money and earned very little. There has been the suggestion today that the enterprise would not have lasted into the future, but maybe it would have continued. We don't know whether a profit would ever have materialized, but considering what they had accomplished by 1848, that might have been possible.

DF: To conclude our conversation, perhaps each of us could take a few moments to relate some final thoughts about Hill and Adamson and their work. This dis-

cussion certainly has been enlightening—not only about the two photographers and their partnership but also about the important role Scotland played in the very early years of the medium.

AM: This has been a remarkable day. My expertise lies in the years before Hill and Adamson, although I am obviously very interested in what happened after they joined forces in Edinburgh. From the images we've seen today, it's obvious that they had a mysterious, essential, friendly, and harmonious partnership that certainly worked. I'm not sure that we've made any progress toward discovering what their miraculous alchemy was, however. It seems to me that more work could be done studying extant prints and their inscriptions and comparing existing negatives and later prints, all of which would perhaps refine the chronology. The pictures we've seen are just extraordinary.

JR: It's been very interesting for me to spend so much time looking and thinking about this work. What I take away from this discussion is a real appreciation for how these two men were encountering a brand new technology, and how much of what has been done in the last 150 years echoes what they did. They were really at the source of many streams that turned into rivers during the decades following, yet they did this free of any guide, just by the strength of their inspiration and creativity. I think the collaboration obviously informed that. It's intriguing to consider photography being reinvented by Hill and Adamson in Scotland in the context of its being reinvented by today's changes in technology. I wonder what streams will turn into rivers from what we're encountering now.

AL: It's quite amazing that in such a short period Hill and Adamson could produce such volumes of work and do it to such high standards. At the turn of the nineteenth century, James Craig Annan recognized and appreciated these magnificent images some sixty years after they were made. Here we are at the turn of another century, and we continue to be enthralled with Hill and Adamson's work. Many questions remain as to the true dynamics of the partnership. While we can speculate about their individual roles, the fact remains that together, in synergy, they succeeded in producing works of outstanding beauty and technical virtuosity. These images attest to the success of Hill and Adamson, one of the first and most successful collaborations in the history of photography.

SS: I am in the very happy position of having come into the history of photography by the accident of being the person standing next to the cupboards with the Hill and Adamson pictures when the auditors came in and said, "Catalog those." Their work in effect taught me about photography, and I was extraordinarily lucky to start with this collection, simply because of its remarkable versatility. I keep thinking that I've surely seen and thought about everything by now, but then I find they can yet again call me back and draw my attention to something new I have never noticed before. Today has indeed added to my understanding and knowledge.

For me, Hill and Adamson are the basis of the National Photography Collection of Scotland and the main justification, in our view, of the world influence of Scottish photography—which I think is true, without any boasting.

MW: We have been discussing what was a new technology, as Jonathan said, and I think the people who study the history of new technologies find a curious event recurring over and over—that sometimes the earliest practitioners are the greatest inventors. I think in this case Hill and Adamson were the pioneers of photography, and they worked in so many different areas, still life being the only one not represented. Nevertheless, they were pioneers in almost every category—cityscape, landscape, portraiture, genre, tableau vivant—all the things that were to become areas of concentration by photographers to come. They probably were not ever surpassed in some ways; certainly there were people as good, but Hill and Adamson were trailblazers.

I think it's interesting that Annan was able to rediscover Hill and Adamson and bring their work to Stieglitz, but they really fell out of mind again, only to be rediscovered in the 1930s and rediscovered again in the 1970s. It's a tribute to their skill, ability, and genius that today, at the door of the twenty-first century, we can still be looking at their work and discovering wonderful things in it.

WN: What always struck me about Hill and Adamson, from the very first time I looked seriously at the pictures in the Royal Scottish Academy in 1971, was the partnership itself—the product of two completely different individuals who came together and had to figure out how to do something brand new. I have been continuously amazed, as you've heard today in my various questions, about the very

nature of this alliance. I would love to unravel the secret as to who did what, but I know that is impossible.

What strikes me as so important about the collaboration is that photography is perhaps the only one of the visual arts where partnering is invited and welcomed, and at least in the twentieth century, seems to be a fundamental creative pattern. There is an enormous span of time between Hill and Adamson and the middle of the twentieth century, when the idea of creative partnerships in the visual arts arose. Jean Arp and his wife, Sylvie Tauber, were among the very first paired artists of the twentieth century, as were Alexander Rodchenko and his wife, with their wonderful partnership in the 1920s. But think of how many really important duos have existed since 1970—Bernd and Hilla Becher, Anne and Patrick Crolier, Helen and Newton Harrison, Gilbert and George, Mike and Doug Starn, Komar and Melamid, McGough and McDermott. Half of those names suggest they are married couples, where the classic partnership was allowed to exercise its magic, but the other instances are men who have come together to share a partnership and to admit to each other that they could not do what they're doing alone. In this regard Hill and Adamson anticipated a major tendency of the second half of the twentieth century, and in doing so again proved themselves to be pioneers.

I want to thank you all for being here today. It's been a great pleasure to hear what you've all said and to be able to view our collection through your eyes.

David Octavius Hill and Robert Adamson.
The Royal Institution, Edinburgh, 1843–47. Salt print, 20.5 × 14.5 cm.
84.XO.734.4.4.5.

Chronology

1802

David Octavius Hill (named Octavius as he is the eighth child) is born in Perth, Perthshire, Scotland, to Emilia Murray and Thomas Hill.

1821

One of ten children, Robert Adamson is born on April 26 at the family farm in Burnside, Fife, Scotland, to Rachel Melville and Alexander Adamson. Hill publishes his first work, a set of romantic lithographs entitled *Sketches of Scenery in Perthshire Drawn from Nature and on Stone*. It is issued in six parts over the course of three years by his father, a stationer.

1822

Hill moves to Edinburgh, where he attends the School of Design, studying under the painter Andrew Wilson (1780–1848). At about this time, Hill also studies with the painter Alexander Nasmyth.

1826

Hill joins the Institution for the Promotion of the Fine Arts, which, after receiving a royal charter in 1827, becomes known as the Royal Institution.

1829

Hill and other Scottish painters, increasingly disillusioned with the Royal Institution, join the Scottish Academy, which receives a royal charter in 1838.

1830

Hill is elected secretary of the Scottish Academy, a position he holds until 1869.

1831

Hill prepares illustrations for three titles (*The Abbot, Redgauntlet,* and *The Fair Maid of Perth*) for the first collected edition of the Waverley Novels by Sir Walter Scott.

1832

Views of the Opening of the Glasgow and Garnkirk Railway, featuring illustrations by Hill, is published.

1834

Engravings of Hill's drawings are included in *The Works of Robert Burns.*

1836

Engravings of Hill's drawings are included in *The Miscellaneous Prose Works of Sir Walter Scott.*

1837

Hill marries Ann Macdonald on August 9. *Tales and Sketches by the Ettrick Shepherd James Hogg* features engravings by Hill.

1838

The Poetical Works of the Ettrick Shepherd is illustrated with Hill's work. The St. Andrews Literary and Philosophical Society, with interests in archaeology, medicine, natural history, and optics, is established in April. Dr. John Adamson, Robert's older brother, and Sir David Brewster, a physicist, both become members.

1839

On January 7 Louis-Jacques-Mandé Daguerre publicly announces the discovery of photography at the Académie des Sciences in Paris. Prompted by the announcement of the daguerreotype process, William Henry Fox Talbot exhibits some of his photogenic drawings at the Royal Institution in London on January 25. On January 31 he presents a paper at the Royal Society entitled "Some Account of the Art of Photogenic Drawing." Within a matter of days Talbot sends his friend Brewster examples of photogenic drawings, which are exhibited at the St. Andrews Literary and Philosophical Society at the beginning of March. Hill's first daughter, Charlotte, is born (a second daughter, born in 1840, dies within a number of hours).

1840

Talbot, continuing to experiment with the photographic process, creates the calotype, a negative-positive print. The penny postage system, a relatively cheap and efficient method of mail delivery, is established for the British Isles in May. *The Land of Burns,* illustrated with Hill's paintings of Scottish scenes pertaining to the life and poetry of Robert Burns, is published. Many of these paintings are exhibited at the Royal Scottish Academy. Hill's wife dies.

1841

Talbot patents his "photographic pictures" in February but upon Brewster's advice does not extend this restriction to Scotland. In May, Talbot sends Brewster details and chemicals for making calotypes; Brewster in turn passes them on to John Adamson and Maj. Hugh Playfair, colleagues at St. Andrews University, who are keen to master the new process. That month, John Adamson successfully creates the first calotype in Scotland (collection of the Royal Museum of Scotland); the subject is his sister Melville Adamson. In November, Brewster sends Talbot examples of John Adamson's work.

1842

John Adamson instructs Robert Adamson in making photographs. In August, Brewster informs Talbot that Robert Adamson is considering practicing photography professionally in Edinburgh. In the fall, Brewster again contacts Talbot and urges him to support the work of Robert Adamson. The Adamson brothers, acknowledging Talbot's initial discovery of the calotype, send him a small album of their work (the Tartan Album; Fox Talbot Museum, Lacock Abbey, England).

1843

An article in the January issue of the *Edinburgh Review* states: "We have now before us a collection of admirable photographs executed by Dr. and Mr. Robert Adamson,

Major Playfair and Captain Brewster. Several of these have all the force and beauty of the Sketches of Rembrandt, and some of them have been pronounced by Mr. Talbot himself to be among the best he has seen. . . . All these calotypes were taken by means of the excellent camera obscura constructed by Mr. Thomas Davidson, optician in Edinburgh. . . . Mr. Robert Adamson, whose skill and experience in photography is very great, is about to practice the art professionally in our northern metropolis." Robert Adamson sets up his photographic studio at Rock House, Calton Hill Stairs, Edinburgh, on May 10.

On May 23 a breakaway group from the Church of Scotland establishes the Free Church of Scotland with an official signing ceremony at Tanfield Hall, Edinburgh. The next day, Hill, who was an onlooker at the signing ceremony, advertises in *The Witness* a proposed engraving "from a Picture to be painted by D. O. Hill." The commemorative canvas is expected to take two or three years to execute. The advertisement runs again on June 1 and 17. By June 9, Brewster introduces Hill to Robert Adamson, suggesting that the two men work together using photography as a quick and efficient means of obtaining portraits of the ministers for the painting. Hill becomes smitten with the medium and enters into partnership with Adamson in July. On July 8 the two men advertise that their calotypes are on display in a gallery on Princes Street that belongs to Hill's brother Alexander.

In October the Free Church of Scotland holds its second General Assembly, in Glasgow. Hill and Adamson travel there to continue photographing ministers. In the late fall more of their work is exhibited, this time at the Board of Manufactures, Edinburgh. The partnership is awarded a prize of £10 for their calotypes. Adamson leaves Edinburgh sometime in mid-November to return home to Burnside, Fife, for the duration of the winter months.

1844

Robert Adamson returns to Edinburgh in April. Shortly thereafter, Hill moves into Rock House. The partnership probably acquires a large camera from Davidson sometime before the middle of June. A selection of the calotypes made in 1843 are exhibited at the Royal Scottish Academy, including portraits of Brewster, Rev. James Julius Wood, Sir William Allan, and Charles Sobieski Stuart. An advertisement in the *Edinburgh Evening Courant* of August 3 reveals that Hill and Adamson plan to prepare six volumes of calotypes, "the subjects selected and arranged by D. O. Hill," and "the chemical manipulations by Mr. Robert Adamson." In September a selection of Hill and Adamson's work is exhibited at Mr. Grundy's Repository of the Arts in Liverpool. The same month, Alexander Christie, Director of the Ornamental Department of the Trustees Academy, Edinburgh, takes some of Hill and Adamson's calotypes to Paris, showing them at the Académie des Sciences. Also in September, Hill and Adamson travel to the annual meeting of the British Association for the Advancement of Science in York, England. They photograph participants of the conference as well as much of the surrounding architecture, including the nearby Durham Cathedral (pl. 21). In October, Talbot travels to Edinburgh to make calotypes for his book *Sun Pictures in Scotland*. He photographs the Scott Monument (p. 119), then nearing completion on Princes Street.

1845

Early in the year Hill sends a portfolio of calotypes to Dominic Colnaghi in London. Hill is elected a member of the Royal Scottish Society of the Arts (now the Royal Society of Edinburgh). Hill and Adamson again exhibit at the Royal Scottish Academy; they show ten calotypes made in 1844, including portraits of John Stevens, a Newhaven pilot, and a Newhaven fishwoman. Hill describes these calotypes as "specimens" that he and Adamson are "preparing for publication." Talbot publishes *Sun Pictures in Scotland* in the summer. In July the 92nd Gordon Highlanders arrive in Edinburgh and are stationed at Edinburgh Castle.

1846

January is noted as being unusually hot and sunny, affording Hill and Adamson the opportunity to make photographs early in the year. In the spring Hill sends large quantities of calotypes to John Murray, a London publisher, in the hope that the work would be bound in volumes and marketed. In April, Hill and Adamson photograph the 92nd Gordon Highlanders (pls. 8–9). The artists publish *A Series of Calotype Views of St. Andrews* (p. 145).

1847

In an August 12 letter to the painter David Roberts, Hill states: "Adamson has been so poorly for many months that our calotyping operations have gone on but slowly." To Lady Ruthven in December he writes: "I am preparing a calotype volume of 100 calotypes which I hope soon to show your ladyship. With its publication, the art and I will probably part company." The same month, Adamson retires to St. Andrews.

1848

Adamson dies on January 14. In a letter to John Scott at Colnaghi's dated October 25, Hill refers to Adamson as his "lamented friend." Hill tries in vain to have Colnaghi's produce large albums of their existing work.

1850

Hill presents Lord Cockburn with an album of photographs.

1851

Calotypes by Hill and Adamson, from Alexander Hill's existing stock, are sold at the Great Exhibition in the Crystal Palace, London.

1852

Hill presents five hundred photographs mounted in albums to the Royal Scottish Academy.

1854

In March, the work of Hill and Adamson is exhibited in Edinburgh alongside that of Thomas Keith (1827–95), George Washington Wilson (1823–93), and Gustave Le Gray, among others.

1856

Although seemingly not working directly with a camera, Hill maintains an interest in photography, joining the Photographic Society of Scotland (other members include Brewster, Keith, and Wilson). Hill presents the Society with a number of large calotypes that are put on display at the Society's first exhibition.

1861

Hill enters into partnership with the Glasgow printer and engraver Alexander McGlashan. They produce albumen prints (from wet collodion negatives) that are very

A SERIES

OF

CALOTYPE VIEWS

OF

ST. ANDREWS.

PUBLISHED BY
D. O. HILL AND R. ADAMSON,
AT THEIR CALOTYPE STUDIO, CALTON STAIRS, EDINBURGH.

MDCCCXLVI.

David Octavius Hill and Robert Adamson.
A Series of Calotype Views of St. Andrews, 1846.
Title page photograph by Robert Adamson, circa 1843.
Salt print, 9 × 10 cm. 84.XO.965.1.

different in look and feel from the earlier calotypes Hill had made in collaboration with Adamson. Hill and McGlashan publish *Contributions towards the further development of Fine Art in Photography,* an album of fourteen images.

1862

In November, Hill marries the sculptor Amelia Paton, sister of the painter Joseph Noel Paton. Hill's daughter, Charlotte, dies.

1866

Hill finally completes the Disruption Picture. The finished work is a curious arrangement, with rows of heads, many of which were altered through Hill's aging process of applying beards, gray hair, and spectacles. One critic likens the ranks of ministers to rows of potatoes. Because more than two decades had passed since the historic event, the original plan for selling engravings is not successful. In the end, the Free Church buys the oil for a reduced rate of £1,500. Regardless, Hill commissions Thomas Annan (1829–87) to make a wet collodion negative of the painting from which carbon prints are produced (see foldout).

1869

Hill leaves Rock House for Newington, on the outskirts of Edinburgh; Annan occupies the studio and takes over existing stock, including prints, negatives, and equipment.

1870

Hill dies on May 17.

1880

Andrew Elliot (1830–1922), Hill's nephew, commissions Thomas Annan's firm to produce carbon prints of Hill and Adamson's pictures.

Circa 1890

James Craig Annan makes reprints of Hill and Adamson's work and also produces photogravures from original negatives.

1898

In April, the Royal Photographic Society in London holds a Hill and Adamson exhibition, with sixty-two works on display.

1899

An exhibition of Hill and Adamson's calotypes is held at the Seventh International Exhibition of the Art of Photography in Hamburg.

1905

Alfred Stieglitz includes a number of photogravures by James Craig Annan of the photographs of Hill and Adamson in the July issue of *Camera Work.*

FOLDOUT

Thomas Annan.
"The Signing of the Deed of Demission" (The Disruption Picture)
by David Octavius Hill (painted 1843–66), 1866.
Carbon print, 26.6 × 60.2 cm.
The Metropolitan Museum of Art, New York, Gift of Robert O. Dougan, 1976 (1976.516).
The painting, in the collection of the Free Church of Scotland, is 152 × 344 cm.

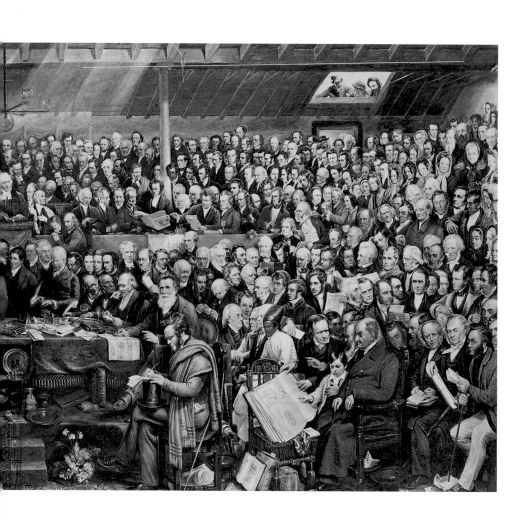

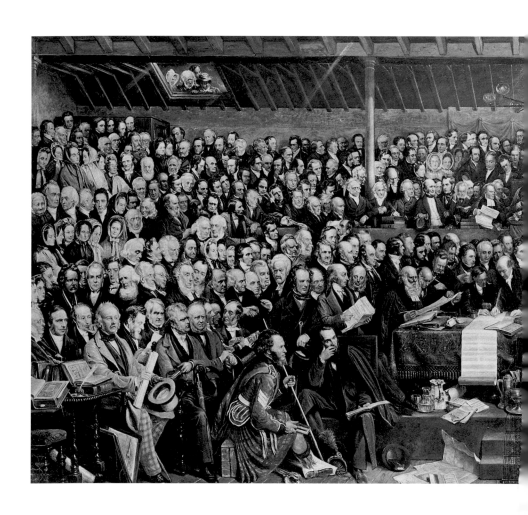

Attributed to John Adamson or Thomas Rodger.
D. O. Hill, c. 1855.
Salt print, 19.9 × 17.5 cm. 84.XM.445.9.

Editor	Gregory A. Dobie
Designer	Jeffrey Cohen
Production Coordinator	Stacy Miyagawa
Photographers	Charles Passela
	Ellen M. Rosenbery
Printer	Gardner Lithograph
	Buena Park, California
Bindery	Roswell Bookbinding
	Phoenix, Arizona